COMICS CRASH COURSE

Vincent Giarrano

IMPACT
CINCINNATI, OHIO
www.impact-books.com

Acknowledgments

Larry Hama

Archie Goodwin

Kathleen Giarrano

Clem Robins

Michael Murphy

Dave Roman

Dan Fraga

Heather Springsteen

Sheldon Mitchell

Other fine Impact Books are available from your local bookstore, art supply store or direct from the publisher.

08 07 06 05 04 5 4 3 2

Library of Congress Cataloging in Publication Data
Giarrano, Vincent.
 Comics crash course/ Vincent Giarrano.— 1st ed.
 p. cm
 Includes index.
 ISBN 1-58180-533-0 (pbk. : alk. paper)
 1. Comic books, strips, etc.—Technique 2. Drawing—Technique. I. Title.

NC1764 .G53 2004
741.5—dc22 2004043969

Edited by Bethe Ferguson and Christina Xenos
Designed by Wendy Dunning
Page Layout by Karla Baker
Production coordinated by Mark Griffin

Metric Conversion Chart

To convert	to	multiply by
Inches	Centimeters	2.54
Centimeters	Inches	0.4
Feet	Centimeters	30.5
Centimeters	Feet	0.03
Yards	Meters	0.9
Meters	Yards	1.1
Sq. Inches	Sq. Centimeters	6.45
Sq. Centimeters	Sq. Inches	0.16
Sq. Feet	Sq. Meters	0.09
Sq. Meters	Sq. Feet	10.8
Sq. Yards	Sq. Meters	0.8
Sq. Meters	Sq. Yards	1.2
Pounds	Kilograms	0.45
Kilograms	Pounds	2.2
Ounces	Grams	28.4
Grams	Ounces	0.04

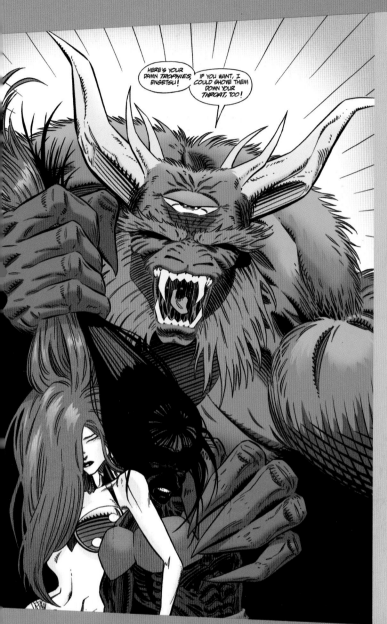

FOREWORD

by Clem Robins

It is a pleasure to introduce *Comics Crash Course*, a comprehensive guide to the art of comic book drawing. Few books on this subject are actually authored by working professionals, but Vincent Giarrano has penciled and inked for every major comic book publisher for two decades, producing some of the most consistently exciting work I've seen. He has drawn mainstream characters such as Batman, Superman, Spider-Man, Dr. Fate, and many others. He both wrote and drew *Redblade* for Dark Horse Comics, fusing manga and current American styles. He also wrote and illustrated a children's book, *Professor Swizzle's Robots*. He usually pencils and inks his own work, but his work has been inked by others, and he has inked other artists' pencils as well. As such, he's thoroughly acquainted with the collaborative process of comics. This wide range of experience is brought to bear in every word and demonstration you'll find in these pages. He knows what he's doing, and his methods reveal it.

Many illustrators use a story to simply showcase their own talents, but Giarrano's work is always intensely story-driven. His stock-in-trade is finding the dramatic core of a story and lacing it with steroids. The writer is safe in his hands. At the same time, Giarrano's drawings stand on their own merits. He is a master of pacing, expression, design and every element that makes a story come alive.

The demands of comics are unique, and a student could go through years of art school without learning what you will find in this book. In these pages, Giarrano explains every element of comic book illustration. Much of what follows comes under the heading of *trade secrets*, the sort of stuff usually picked up in an apprenticeship with a comic artist. It is all laid out here for you.

Drawing comics is not an easy way to earn a living. Everyone who has done it has faced the same, seemingly insurmountable, challenge every month: twenty-two blank sheets of bristol board and a manuscript. Without some talent, a lot of courage and a definite procedure, no one could get the work done, month after month. But if you've got the talent and can muster up the courage, *Comics Crash Course* offers direction that could teach you years of instruction and save you a lot of frustration.

Enough. Turn the page and get ready to work. You are in qualified and capable hands.

Clem Robins has provided lettering for every major, and quite a few minor, comic book publishers. He is the author of **The Art of Figure Drawing**, published in 2002 by North Light Books, and teaches figure drawing and artistic anatomy at the Art Academy of Cincinnati.

1 ## Basic Drawing Skills *12*

Start with learning to draw basic shapes and progress through creating your favorite characters and putting them into their own scene. Learn to create alluring expressions, destructive weapons and provocative scenes.

2 ## Storytelling *66*

You can't draw an entire comic in one panel. This chapter shows you how to tell a story with images and teaches different methods of pacing those images. It also covers composition dos and don'ts, visual storytelling techniques, panel layout, dialogue with word balloons and creating a dynamic cover.

3 ## Penciling *86*

Build your comic from the script to pencils. This chapter covers panel layout, using dynamic shot angles and creating catchy splash pages. Try creating your own penciled panel from a sample script.

 Inking *106*

Breathe life into your comics with inking techniques using paint brushes and pens. Create various textures and washtones with these materials.

INTRODUCTION

Welcome, future comic book artists.
I've thought for a long time about
writing this book for you.

When I broke into comics, my first couple of years were terrible. I found that most of what I knew about drawing comics was way off. I didn't know the rules of storytelling or even how to meet my deadlines. I had some good help from my first editor, Larry Hama, but mostly I had to teach myself.

Through trial and error, I eventually discovered how to effectively produce comic work. I developed a really good functional method.

In this book, I'll show you how to break down the process so each step focuses on only one part at a time. This way you're not overwhelmed by the whole job and you can concentrate on the little things—and believe me, there are a lot of little things.

Drawing comics is intense work, but it's also the most fun and creative job you could ever have. What could be better than getting paid to draw ripped super heroes, sultry vixens or cool gadgets? There's no other vehicle that allows one person to have so much creative control over his material.

Comics are like making your very own film. So, once you get to the other side of this book, all you'll need is a story idea and you're good to go. OK, so get going!

The Process

Before you start gathering your tools, it helps to understand the order of the comic making process: constructing a layout sketch, revising it with bluelines, penciling a clean layout, inking the penciled lines and coloring the final piece.

Penciling

Here are the tools and materials you will need for penciling and bluelines.

RULER 18" (46cm) metal with cork bottom for use with Rapidograph pens.

PENCILS No. 2 or HB. I like the Mirado Black Warrior no. 2 pencil, because it has a round grip.

KNEADED ERASER

NON-PHOTO BLUE PENCIL AND LEADS 2mm lead holder and lead pointer or 0.5mm pens.

CIRCLE TEMPLATES AND COMPASS

LIGHTBOX 11" × 17" (28cm × 43cm) or larger. If you can't afford a lightbox, you can make one yourself. Just put one or two short florescent fixtures in a shallow box (preferably wood). For the top, use a piece of white Plexiglas, at least 12" × 18" (30cm × 46cm).

WHITE ARTIST'S TAPE Use two small pieces to keep pages from shifting on the lightbox.

COPY MACHINE ACCESS One that can make enlargements.

PAPER 2- or 3-ply bristol board, vellum or smooth finish; 8½" × 11" (22cm × 28cm) regular; 20-lb. (43gsm) copy paper, 500-sheet pack.

TRIANGLE (30/60/90) Instead of a T-square, slide this along a ruler to make parallel lines. If you prefer a T-square, you'll need to tape your paper onto a small wooden drawing board.

PENCILS

KNEADED ERASER

NON-PHOTO BLUE PENCIL AND LEADS

CIRCLE TEMPLATES

LIGHTBOX
WHITE ARTIST'S TAPE

Inking

Here are the basic tools and materials you will need to start inking your comics.

PEN POINTS Stiff, medium and flexible.

SABLE BRUSHES Nos. 1 and 2.

PEN POINT HOLDERS For all pen point sizes.

INK CUPS A small plastic cup with a screw-on lid; you'll need two if you're using two types of ink.

WHITE CORRECTION PENS Pentel, fine point.

BLACK GREASE PENCIL

TOOTHBRUSH An old, worn one is best.

RAPIDOGRAPH PEN No. 2; nos. 1 and 3 are optional.

INDIA INK A non-clogging type is better for pen points; some brands have a richer black, which is better for brush use.

TWO WATER CUPS The first takes most of the ink out of your brush; the next gives it an extra rinsing.

PAPER TOWELS Fold one piece in quarters and use it to clean your pens and brushes.

WHITE INK Pro White or Pelican Graphic White.

SAFETY RAZOR Use the corner of it to scratch into dried ink. It rips the surface of the paper making rough white lines.

PEN POINTS

SABLE BRUSHES

PEN POINT HOLDERS

INK CUPS

SAFETY RAZOR

WHITE CORRECTION PENS

BLACK GREASE PENCIL

TOOTHBRUSH

RAPIDOGRAPH PEN

SPLASH PAGE
Like a cover and a little like a big panel. It can be a double page spread, but it's usually placed in the first few pages of a comic book.

Title

Caption

Credits

Panel

Panel border

Indicia area
This is a block of copy with publishing and copyright information. It can be placed in the first few pages or on the inside cover.

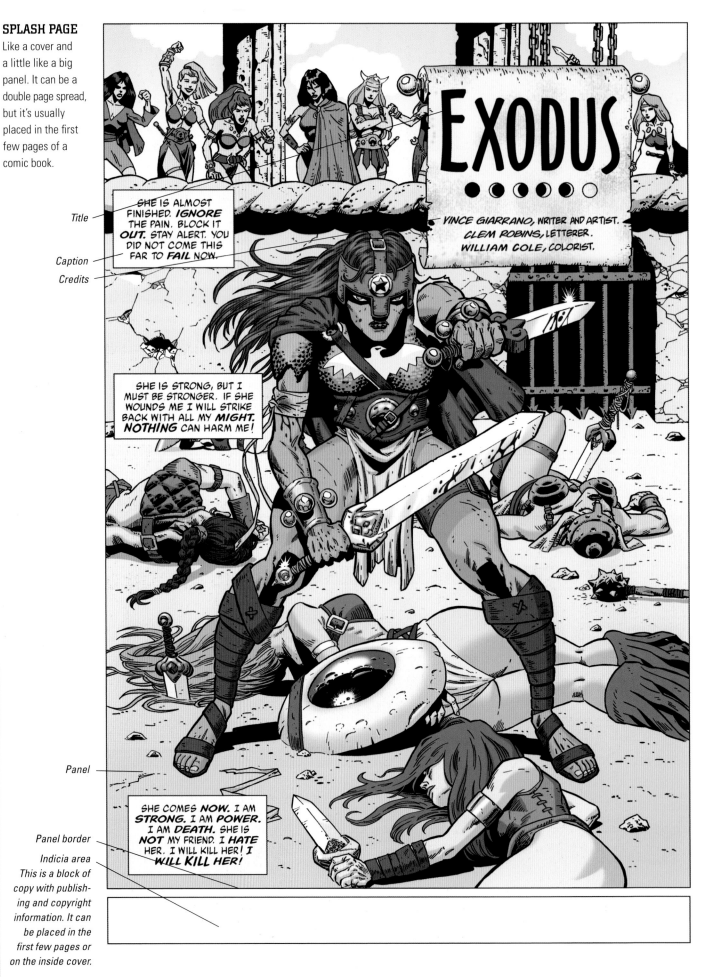

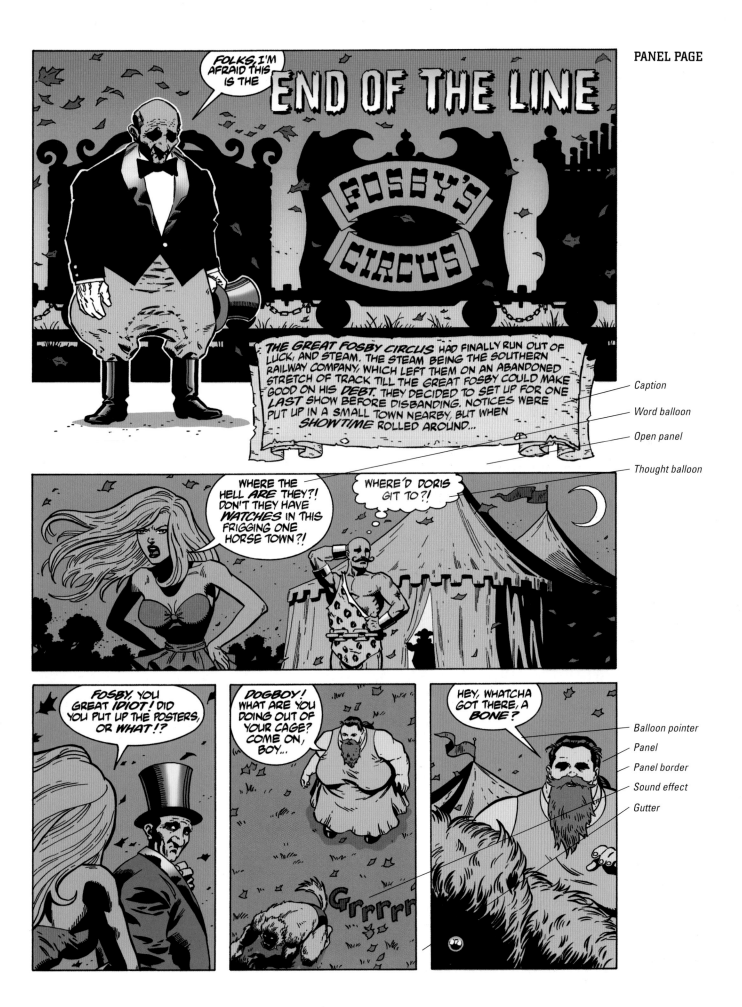

Caption

Word balloon

Open panel

Thought balloon

Balloon pointer

Panel

Panel border

Sound effect

Gutter

1 BASIC DRAWING SKILLS

Welcome to basic drawing 101. I'm sure you want to get right to drawing superheroes, but first there are a few important things we need to cover. As your official instructor, I'm going to show you how to draw all the different elements that go into a comic panel. We'll start out with basic shapes and take that into creating people, objects and scenes. I'll show you how to come up with cool costumed characters and walk you through my process for constructing and designing them. This chapter is mainly for beginners, but even if you know this stuff, there are many helpful tips.

Basic shapes are ground zero for drawing comics. Making shapes look three-dimensional is the foundation for all the cool stuff you'll be drawing. Your figures, backgrounds and objects will all be made up of these basic shapes.

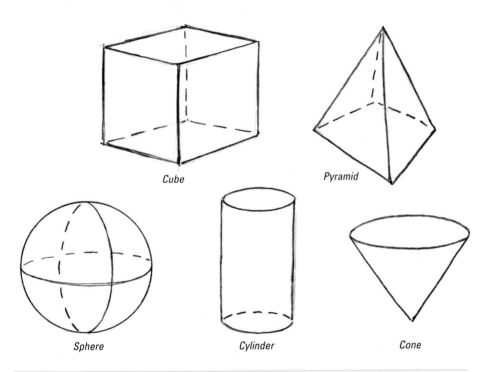

Cube

Pyramid

Sphere

Cylinder

Cone

LEARN THE FIVE BASIC SHAPES

Draw these shapes from different angles and get used to visualizing their structure—as if they were transparent.

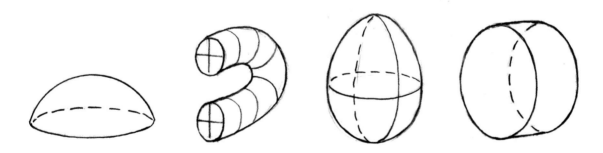

PRACTICE VARIATIONS ON THE BASIC SHAPES

Here are some variations on those basic shapes. Practice by doing many pages of shapes like these. Look at objects around you or in comic books to help until you are able to draw them from your head. Congratulations, you're on your way to becoming a real comic book artist.

ow you're ready to draw some more complicated subjects. The first step in drawing anything is to establish the form using basic shapes. This is important because it creates a good foundation upon which to build your finished drawing. I find it helpful to first lightly block out the major shape of my object, as you see here in gray. This also acts as a guide for the shapes within and keeps them lined up, or in the same perspective. For more information on perspective, see page 58.

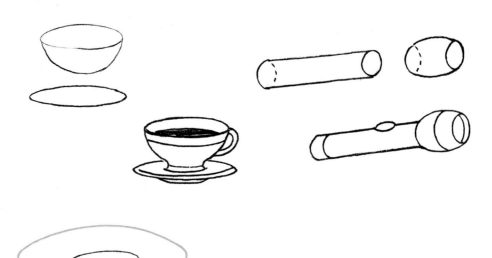

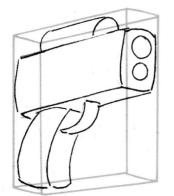

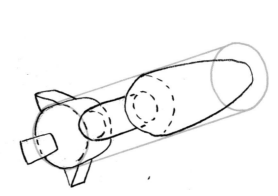

L et's apply basic shape construction by drawing a car. The starting point here is to block in the overall shape, shown below in gray.

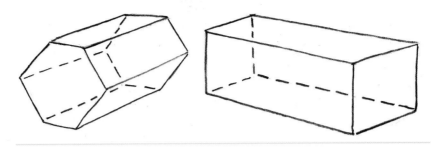

START WITH A BOX
It helps to establish this box first, so the car shape is accurate and also so it matches the background perspective.

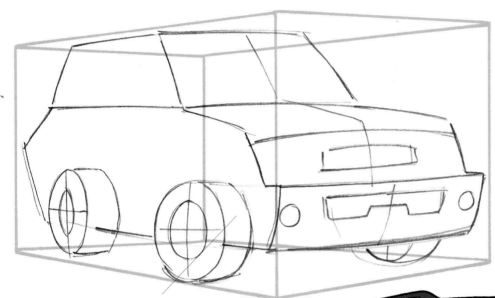

USE SHAPES TO FORM THE CAR
Draw the car using simple shapes: cylinders for wheels, a box for the body and boxes for the windows and roof. There you have it—your basic form, solidly constructed.

Since the wheel is turned, the cylinders for the front tires are at a different angle than the back tires.

FINISHING DETAILS
At this point you could use a reference photo to add detail and further refine your shapes.

Give Vehicles Personality

When you draw a car, look for attributes that create its character. For instance, the bumpers on this car have a unique shape. Look for those shapes that really stand out. This is just like capturing someone's personality when drawing a face. Is his nose straight, turned up or shaped like a potato?

Even if you want to draw things that don't exist, it still comes down to basic shapes. Start with the big, simple shapes and then develop smaller shapes within those. For example, the front lights on this submarine are just a bunch of cylinders inside a larger cylinder.

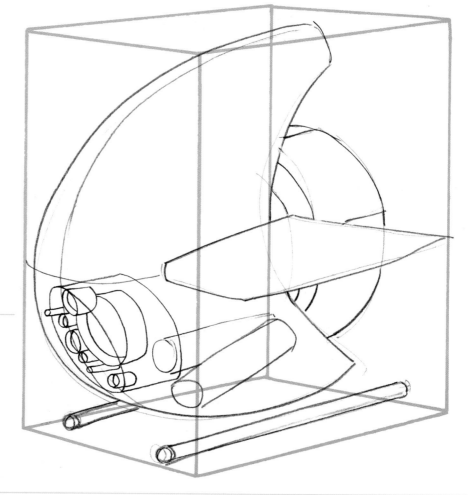

SHAPE THE SUBMARINE

Block in the overall shape. Next, use your imagination to create the interesting shapes that will form the submarine. Don't worry too much about details now. The important thing is to create a solid, accurate form for your drawing as well as a pleasing arrangement of shapes that feel like a submarine.

ADD FINAL DETAILS

When creating something like this, you need to consider that your made-up vehicle needs to convince the reader that it could possibly work. I find it helpful to look at books with anime or film designs. These books have tons of great ideas for drawing functioning devices.

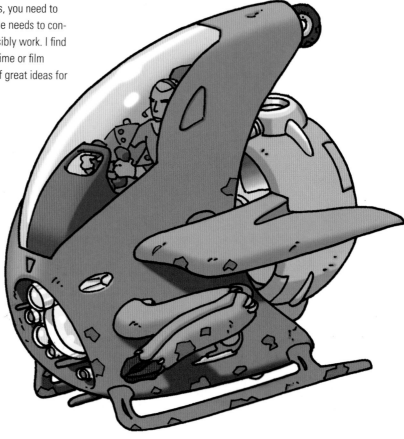

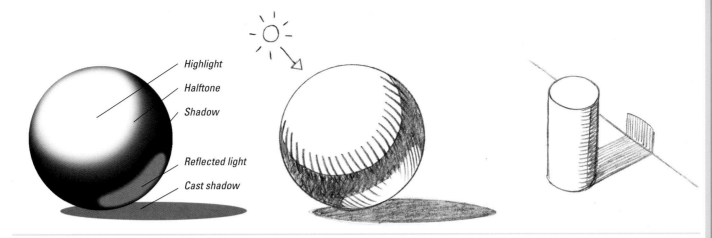

Shading plays a big part in describing forms and creating an atmospheric mood. Linework on its own presents a somewhat flat image. Using shading and shadows allows you to create more solid-looking shapes. For comics, the elements of shading need to be simplified for printing (as you can see with the redrawn sphere above). As you practice your shading, remember to first figure out where your light source is located so you will know where the shadows and lights will fall.

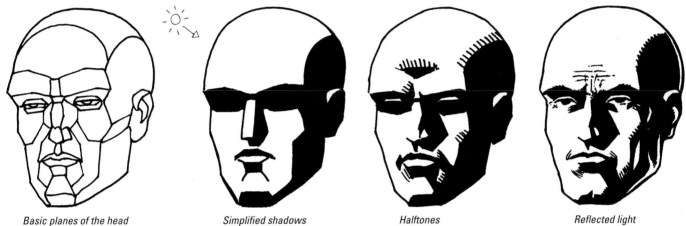

Basic planes of the head *Simplified shadows* *Halftones* *Reflected light*

These first three heads show you the progression for shading this form. Think about the planes of the face as you sketch them in. As you improve, you can just simply block in the shadows as shown in the second and third heads. Don't start by putting in detailed shadows right away. Create your structure and begin with simplified forms.

Here are a couple examples of using shadows to create a more solid-looking object.

Light and Shadow

These are the five aspects of light and shadow:

HIGHLIGHT: The area facing the light source and receiving the most light.

HALFTONE: The transition between your highlight and shadow.

SHADOW: The darkest area of an object.

REFLECTED LIGHT: Light from the source bounces off an object and creates a light area within the shadow, but it is never as bright as the highlight.

CAST SHADOW: The silhouette of an object projected opposite the light source.

Whether you want to create that film noir look or just add a dark element to your superheroes, shading and shadows are the way to go. They add dimension to your image and control the mood of your scene. If it's a happy, easygoing scene, don't use them very much. If it's tense, scary or ominous scene, use them a lot. You can also use shadows as a short cut when you're blocking out areas, so you don't get stuck drawing everything.

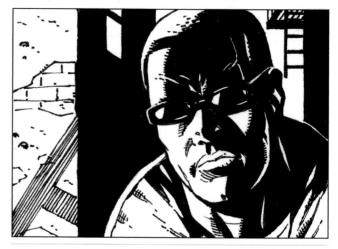

SINGLE LIGHT SOURCE WITH SOME REFLECTED LIGHT

This combination of light and shadow is a standard type of mood lighting for comics.

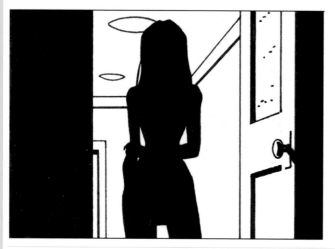

SILHOUETTE

This is a great effect because the reader contributes to the image, subconsciously filling in what's not drawn.

CAST SHADOWS

These are good for helping define surrounding shapes. Here, it also symbolically ties the figure to his dark deed.

MULTIPLE LIGHT SOURCES

Use multiple light sources to create a more complex image.

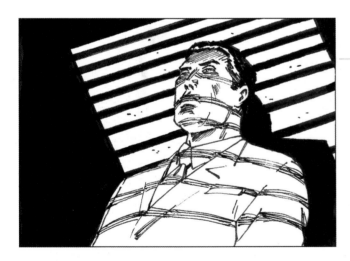

BOTTOM LIGHTING

Bottom lighting adds a dramatic effect to any scene—especially to create suspense.

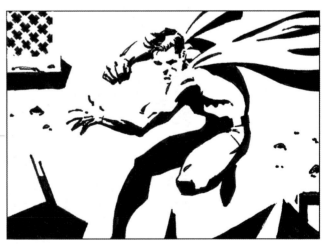

ORTHOGRAPHIC EFFECT—EXTREMELY BRIGHT LIGHT

You can also use this effect as a cool graphic effect for a panel, just to break things up. In other words, it's not bright light, it's just a way of stylizing an image to add some variety to your comic page.

ere's where you can have some real fun. Drawing the figure is the best part of comic book art. It can be intimidating, but my process breaks it down into more manageable stages. You don't want to start with a finished figure, you need to start with a rough sketch and work up to it.

Don't Press Too Hard

Pencil lightly in these stages so you can easily change things. If your sketch gets too dark or messy, use a lightbox to transfer your drawing onto new paper.

GESTURE DRAWING

The first step in drawing your figure is the gesture sketch. With this sketch, you want to capture the flow or rhythm of your character's pose. Use quick, simple lines to establish the torso, legs and arms. Next, use two straight lines to determine the angle for the shoulders and hips. An oval with a horizontal and vertical axis is all you need at this point to show the head and the direction it faces. It's very easy at this stage to change your pose, so rework your gesture until it looks and feels right.

BLOCK IT IN

Once you have the gesture of your pose, begin blocking in the major parts of the body with basic shapes. As you do this, keep in mind the following:

- **Three-dimensional shape:** Create the body mass using cubes, cylinders, spheres, etc.
- **Body part direction:** Use a cross division on the head and chest to establish their direction.
- **Foreshortening:** Shapes that are closer to you appear larger than they actually are.
- **Proportions:** Estimate the general proportions of the body—no need to be too exact.

Now you can see if your pose is working. If not, it's still easy at this point to tweak or change it altogether.

The figure on the left shows you more clearly the shapes that I'm imagining as I sketch the figure on the right.

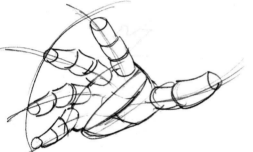

As your drawing ability increases, the way you block in your figure will change. This is what my construction looks like. Start with a gesture and flesh out the figure in a sketchy way. This technique also allows for happy accidents to occur. Happy accidents are when you've involuntary created something interesting with your many lines that you'd like to keep.

Hands are like little figures, so follow the same steps: First sketch their gesture and then construct the hands with shapes. Look at your own hand and use a mirror to see various angles.

Sketch Different Poses

Practice sketching figure poses like this as much as possible. Challenge yourself by twisting the figure, and drawing the limbs in many different positions. The more you practice the better you'll get. Many artists sketch these poses as a warm-up exercise before they start their comic work.

You'll find that proportions vary quite a bit in comics, especially between superheroes and normal characters. Pushing proportions one way or another is very common. Notice how different people's shapes are—long torso or short legs, wide or narrow hips. Don't stress over proportions too much; the important aspect is achieving the impression you want to make with your figure. If that means drawing something out of proportion, then that's exactly what you need to do.

Here are basic examples of male and female proportions. The height for a normal person is about eight to eight and a half heads. Familiarize yourself with proportions, but don't bother trying to count heads or measure things every time you draw a figure. The reality is that when you're drawing figures in comics, you rarely have poses that allow for precise measuring.

Shoulder to elbow: Notice where the elbow cuts across the torso

Shoulder width: Men have much wider shoulders than women

Collarbone to waist

Elbow to wrist: Notice where the wrist cuts across the torso

Hip to knee

Knee to ankle

I put a heavy outline on the female to emphasize the contour shape of her body. Women don't usually have the muscle definition that men do, so the contour is what describes their form.

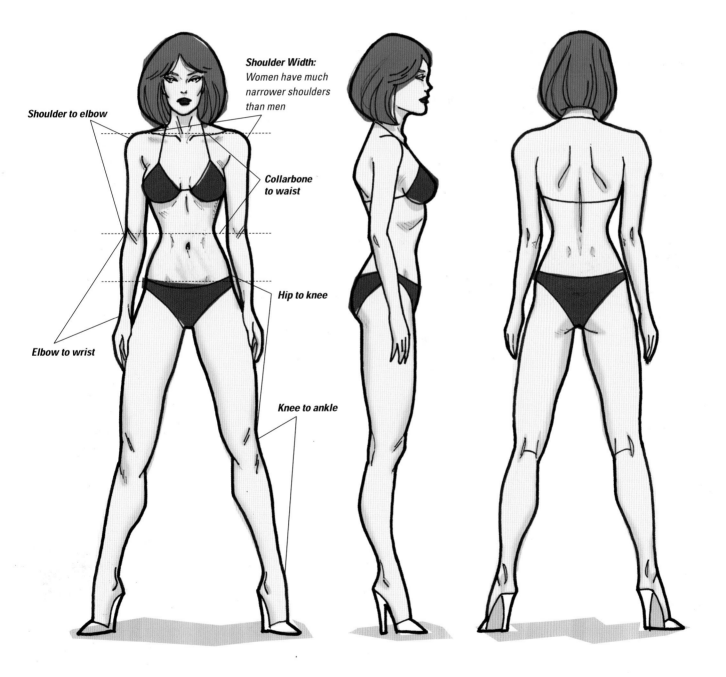

Shoulder to elbow

Shoulder Width:
Women have much narrower shoulders than men

Collarbone to waist

Hip to knee

Elbow to wrist

Knee to ankle

Real anatomy is just a starting point. For it to work in comics, it needs to be translated into more of a graphic design. Learn as much real anatomy as you can, but eventually what you will achieve is your own stylized interpretation of it. Here I've broken down the muscles into simple shapes, sort of a shorthand for anatomy. Avoid becoming too mechanical with your anatomy. You don't want to draw the same body on every character.

Use Magazines as a Guide

Try sketching from bodybuilding magazines. You'll learn anatomy as well as how real muscles change with flexing and twisting. Notice how much muscle shapes can vary from one person to another. I've also videotaped bodybuilding competitions. Playing it back and pausing it helped me to understand how muscles transform.

Notice that when a limb moves or twists, different shapes are created. Arms are where you see this the most.

Muscles change shape as you move. Every movement involves muscles contracting and relaxing. Get to know the areas of the body that change the most in this way.

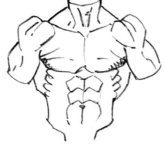

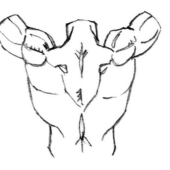

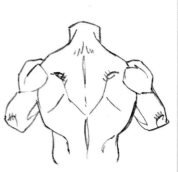

Chest with arms up
Notice the muscles stretch out and the torso is elongated. Also, the underside of the arm is exposed.

Chest with arms down
Here muscles are more compressed and flexed.

Back with arms up
As the front is stretched, the back is also flexed.

Back with arms down
Notice how muscles are different when flexed or relaxed. Render them to fit the action.

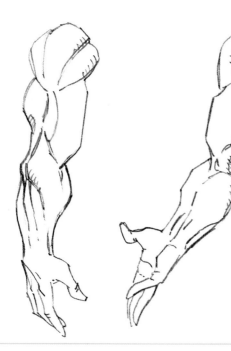

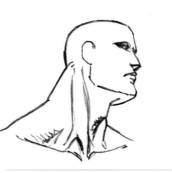

TWISTING NECKS

Just turning the head creates new shapes in the muscles of the neck. Most prominent are the pair that you see here, coming down the side and anchoring at the collar bone.

TWISTING ARMS

As the arm twists, two things happen: muscles change shape and new muscles come into view.

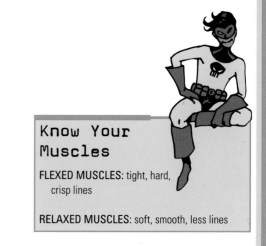

Know Your Muscles

FLEXED MUSCLES: tight, hard, crisp lines

RELAXED MUSCLES: soft, smooth, less lines

Now here's a real challenge for you. Unlike men, women don't have those clearly defined muscles to help you piece things together. Women have large smooth shapes and their form is described mostly by their outer contours. For constructing your females use round shapes and graceful curves.

Keep Female Features Simple

The female form is much more about subtlety than the male form. Over-rendering of features, even though true, will diminish the feminine quality of your character. The general rule for women: Use as few lines as possible. As you can see with this sketch, the hand with the fewest lines looks younger and more feminine.

GESTURE SKETCH

This pose is pushed to create a stereotypical comic female. Some of her proportions are exaggerated to make her more attractive.

For example:

- narrow waist
- large hips
- long neck
- long, thin fingers
- arched back

SIMPLIFY SHAPES

By changing how you pose this character's hand, you can make her seem more feminine. Check out hands in advertisements or fashion magazines to get ideas for this kind of posing.

FINAL DETAILS

As you finish your drawing, try to think about the qualities of skin, such as where it's fleshy and where it's bony. Draw the hair as a stylized shape and treat it as a mass. Don't draw individual strands unless you want a few stray hairs for effect.

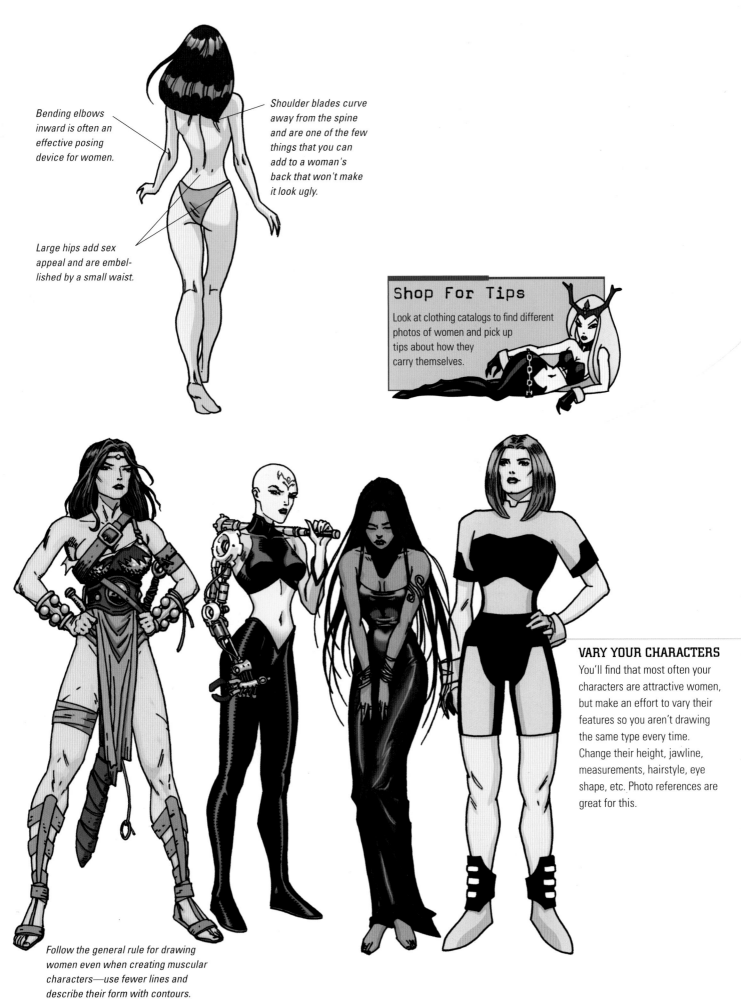

Bending elbows inward is often an effective posing device for women.

Shoulder blades curve away from the spine and are one of the few things that you can add to a woman's back that won't make it look ugly.

Large hips add sex appeal and are embellished by a small waist.

Shop For Tips

Look at clothing catalogs to find different photos of women and pick up tips about how they carry themselves.

VARY YOUR CHARACTERS

You'll find that most often your characters are attractive women, but make an effort to vary their features so you aren't drawing the same type every time. Change their height, jawline, measurements, hairstyle, eye shape, etc. Photo references are great for this.

Follow the general rule for drawing women even when creating muscular characters—use fewer lines and describe their form with contours.

The face is an especially complex form to draw. The musculature can be a little confusing. To help, I've broken it down into a series of interlocking planes. This shows you structure and shape but will be much easier for you to understand.

Here I've created the structure for a standard male face. I've sectioned the head into major planes and some simple shapes.

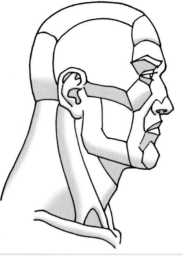

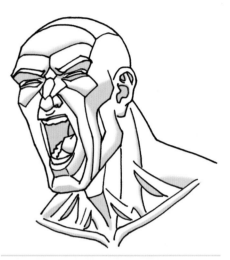

Think of the face as being made of rubber. Notice that the planes change slightly as it stretches. One of its major changes is the movement of the jaw. The hinge for the jaw is located in front of the earlobe.

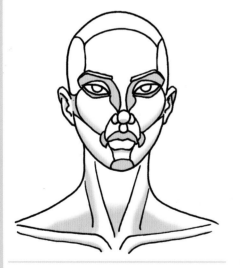

Now let's look at the structure for a female face. Notice that it's a lot less angular than the male face.

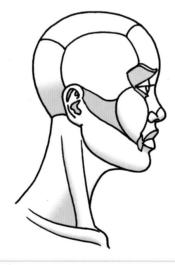

Females also have fewer planes. Their form needs to be simplified in order to appear feminine enough.

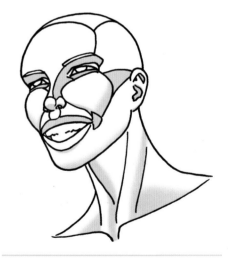

Remember you're not drawing in all these shapes. This is just a model for you to understand the major shapes for the face.

The eyes are a special focal point on characters. They can be used to convey quite a bit: expression, intelligence, beauty, even personality. It's definitely a key element for you to master.

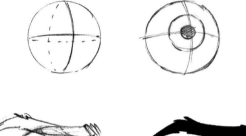
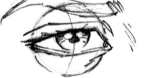
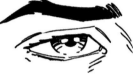
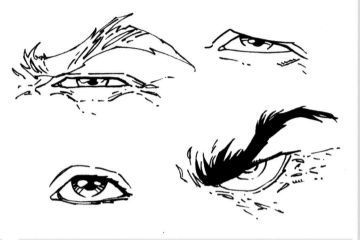

MALE EYES

Remember your basic sphere shape when drawing eyes. The outward appearance is created by how the skin wraps and folds around the sphere. Male eyes are drawn smaller than female eyes. For comic art, the eyebrow is usually bushier for males.

A VARIETY OF EYES

Here are a few examples to show how different eyes can look. Research and draw various eyes from live models, magazines and even comic books. Get to know the different qualities they can possess.

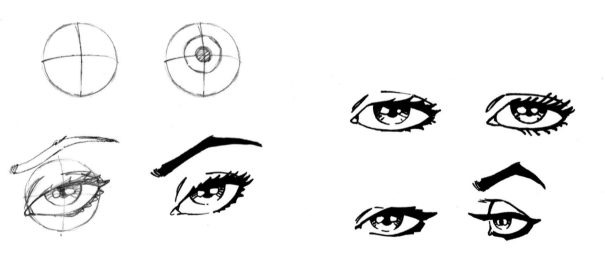

FEMALE EYES

To make an eye look sexy, tip it up on the outside so it's at more of a diagonal angle. Show a little more of the eyelid. For women, the eyebrow is thin and arched.

LUSCIOUS LASHES

Eyelashes work better as one large shape rather than individual hairs, especially for women. The further away you are, the more simple that shape should become.

Let's look at some of the other features of the face. To help you understand what you really need to do, I'm showing you the finish linework for these features. We've covered the structure for these things, but what you need to know now is the stylized way in which they're rendered for comics.

Ears

The shape of the ear is something you should memorize. It's one of those things you draw many times and it helps to know it by heart.

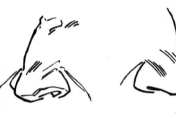

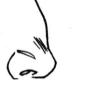

MALE NOSE

Notice that many of the lines are broken. You don't want to define the shapes of the nose with solid, unbroken lines. Those lines may be there in reality, but all you need to do is convey a certain impression.

FEMALE NOSE

Capturing an impression is especially important for the female nose. To have a woman's nose look good, only draw the bare minimum. Except in profile, most female noses are drawn like the bottom three here.

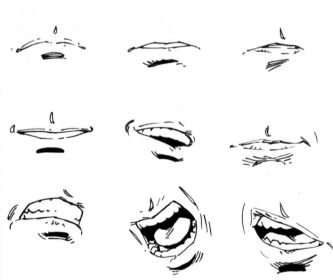

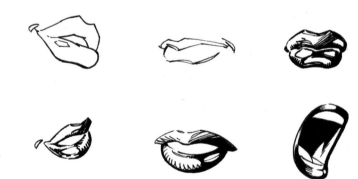

MALE MOUTH

Mouths curve around the teeth. Broken lines serve well for gently defining the lips. Use solid lines for the shapes that are facing away from the light, like the underside of the upper lip. For teeth, it's best not to draw the lines between them.

FEMALE MOUTH

The female mouth is much fuller and uses stronger lines. This relates to the darker shading because of the use of lipstick. Use broken lines on top of the upper lip and on the bottom lip where highlights exist. Women's teeth look best without even a hint of jagged edges. The wider a woman's mouth opens, the thinner and more streamlined her lips become.

OK, let's put together some of what you've learned and draw a standard comic-style male head.

1 Begin the Basic Head Shape
Start by drawing an oval for the basic head shape.

2 Establish Placement of Features
Next, divide the oval in half with a vertical and a horizontal line. The lines will establish the eye placement. Put in two more horizontal lines, the first for the bottom of the nose (halfway between the eye line and the chin) and the second for the mouth (halfway between the nose and the chin).

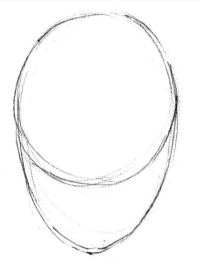

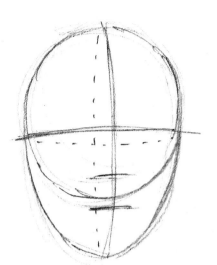

3 Sketch the Features
Place the eyeballs centered on the eye line with roughly an eye's width between them. Use the eye and nose line for the placement of the ears. The top of the ear touches the eye line and the bottom of the ear touches the nose line.

Next, draw the contour of the jaw using the bottom of the oval as a guide. Sketch the features simply for now with just a few lines.

4 Sketch the Hair and Develop the Features
When sketching in the hair, think of it as a solid shape rather than individual strands.

Further develop the features, but keep in mind that this is not a realistic drawing. For comics, you need to use a more stylized way of rendering. For example, notice how the nose is a series of simplified lines.

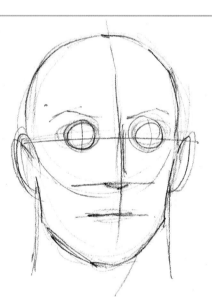

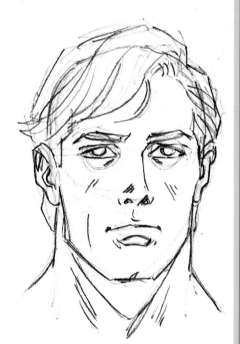

ow try creating a female head. Notice the difference in shape between the male and the female head. Where the male head is more angular and boxy, the female head has more curvy and smooth characteristics.

1 Begin the Basic Head Shape
Begin with your segmented oval and place the centerlines. Then place the feature lines for the nose and mouth.

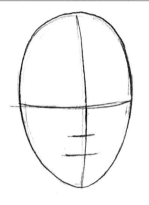

2 Sketch the Facial Features
This is a woman, so we have to make feminine features. For instance, the jawline is less bulky than a man's. I find a rounded triangle works well. Tip the eyes up a little on the outside to make them more attractive. For the nose, just put in three simple lines.

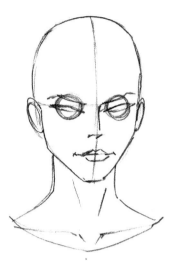

3 Draw the Neck and Hair
Notice that the neck is much narrower than a male's. Once again, treat the hair as a single shape.

4 Add the Finishing Touches
Here you see the end result, inked and colored. Women look better with fewer lines, so keep the features as minimal as possible.

One of the fun parts of drawing comics is creating different kinds of characters. You can do this is by creating different features, altering the proportions of the face and placing facial features, as well as sizing and shaping the head.

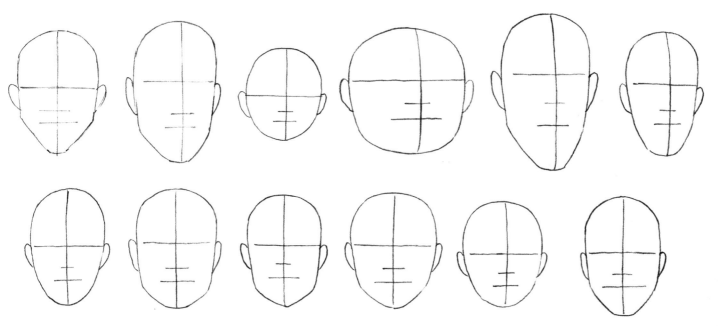

Here are a variety of head shapes with slight variations to their feature lines.

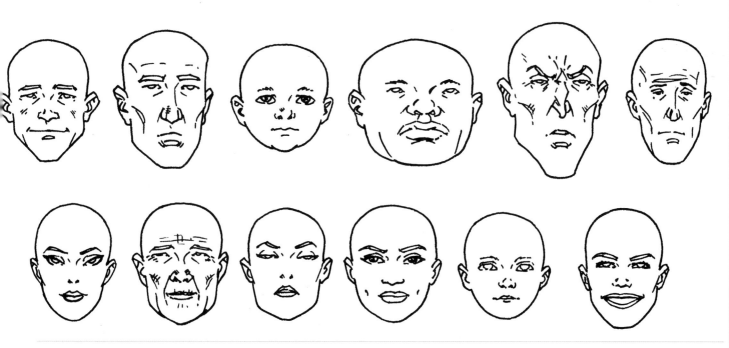

The facial features have a lot to do with the final appearance, but notice how using different facial structures changes each face quite a bit.

You will draw a lot of heads in comics so it's important to be able to draw them from many different angles. The secret is having an accurate way of placing the features on the head.

1 Begin the Head Shape and Plan Feature Location

Start with your basic three-dimensional head shape, then wrap the lines for your features (eyes, nose and mouth) around it.

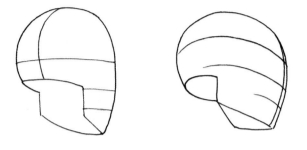
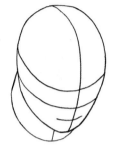

2 Draw the Major Head Shapes

Next, block in the major shapes of the head using your feature lines: the nose, the brow, the ear, the mouth and the chin.

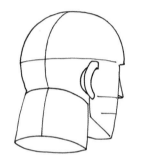
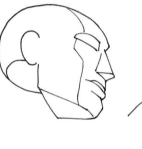
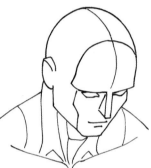

3 Add the Features

Now that you have the basic structure, you can concentrate on the appearance of your character's features.

This is one of those things that you get better at with experience, so go through magazines and practice drawing a lot of heads. You mainly want to become familiar with how the features look from different angles.

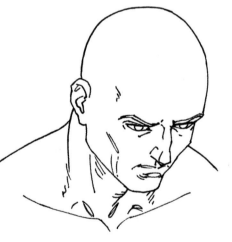

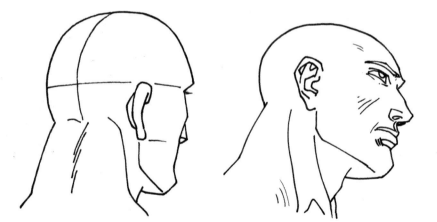

One of your many jobs as a penciler is to act for the characters. Just as in films, there are different types of acting in comics: serious, comedic, realistic, over the top and subtle. Decide which best suits the story you're drawing. Sometimes less acting actually says more. I've found a serious mood can be better achieved by obscuring faces with a shadow or using less descriptive rendering. Look at different artists and notice the different styles of acting in their work.

Take a Closer Look

Put a mirror in front of you on your drawing table and use it to act out expressions. It's also a great help for learning how the face moves.

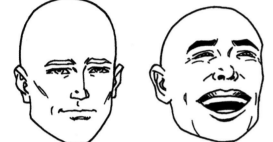
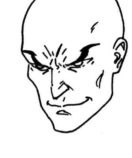
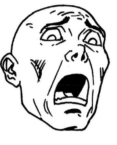
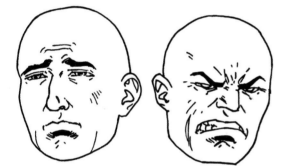

MALE FACES

Imagine that the face is made of rubber. It can easily stretch or scrunch up when expressing itself.

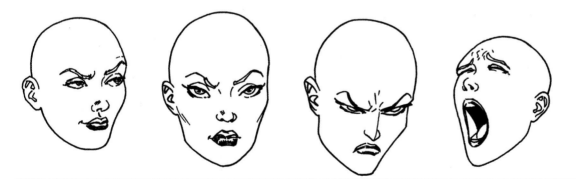

FEMALE FACES

Remember, less lines for females is better. Use the eyes, eyebrows and mouth to convey most of the expression.

This is the meat and potatoes for superhero comics. Ultra-realistic anatomy just doesn't cut it; you need things to be bigger than life. It's all about exaggerating muscles and proportions to create a more visually intense character. Foreshortening is also a big part of making figures more dynamic (see page 40 for more on foreshortening).

This guy doesn't just have big muscles, I also made his hands and feet oversized. I played with his skeletal proportions; notice how wide his shoulders are.

Hey, muscles aren't the only game in town. A heavy physique can also be dynamic. Try handling other body types in an extreme way too, like a tall, thin, sinewy figure, or someone extremely short and stocky. Go as wild as you like and have fun with it.

et's not forget the girls. They can be
dynamic too.

Here's a big-boned gal. I stuck with the same idea
of less lines for women and merely exaggerated
her girth. Keeping her lines smooth and graceful
gives her an appearance of power and strength.

This character's waist, breast size and legs are
exaggerated. Hair is another good element to
make dynamic. If it's long, make it really long. If
it's a sculptured shape, push it to see how big and
wild you can make it.

Getting the right pose can be tricky; sometimes it's hard to tell why it's not working. Here are some things that will put a monkey wrench in your pose.

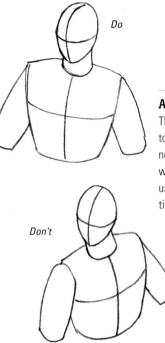

Do

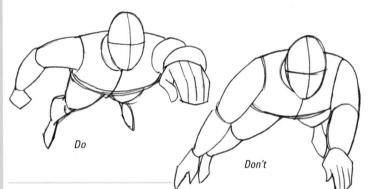

Do

Don't

TANGENTS

This is when objects line up with each other and appear connected but are not. Tangents disrupt the illusion of depth and make your figure look flat. Notice how the right arm and leg are "kissing" each other, thereby joining them visually. You need to clearly show that they occupy separate spaces, especially when two things are that far apart. Either move them apart or overlap them.

AWKWARD ALIGNMENT

These are poses that are contrary to how the body moves under normal conditions. For example, when the head turns, the torso usually turns in the same direction with it. Notice the diagram; it shows more clearly how the head and torso should line up.

Don't

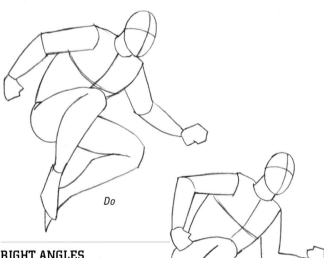

Do

RIGHT ANGLES

Avoid strong, perfect right angles in your poses because they can look very odd and unnatural. Use diagonals instead.

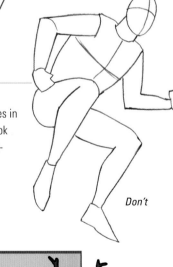

Don't

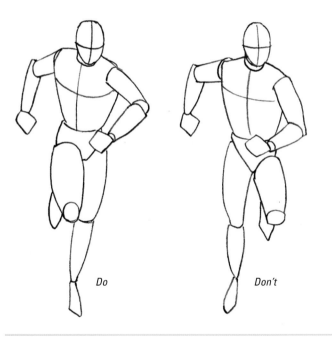

Do

Don't

MOVEMENT

When drawing a figure running or walking, remember that if the arm is forward on one side of the body then the leg on that side is back, and vice versa.

Don't let yourself get lazy about posing. Redo a pose as many times as it takes for you to achieve the best solution.

Get Feedback

If you can't tell where a pose isn't working, have someone else look at it. A fresh eye may be able to spot a problem area.

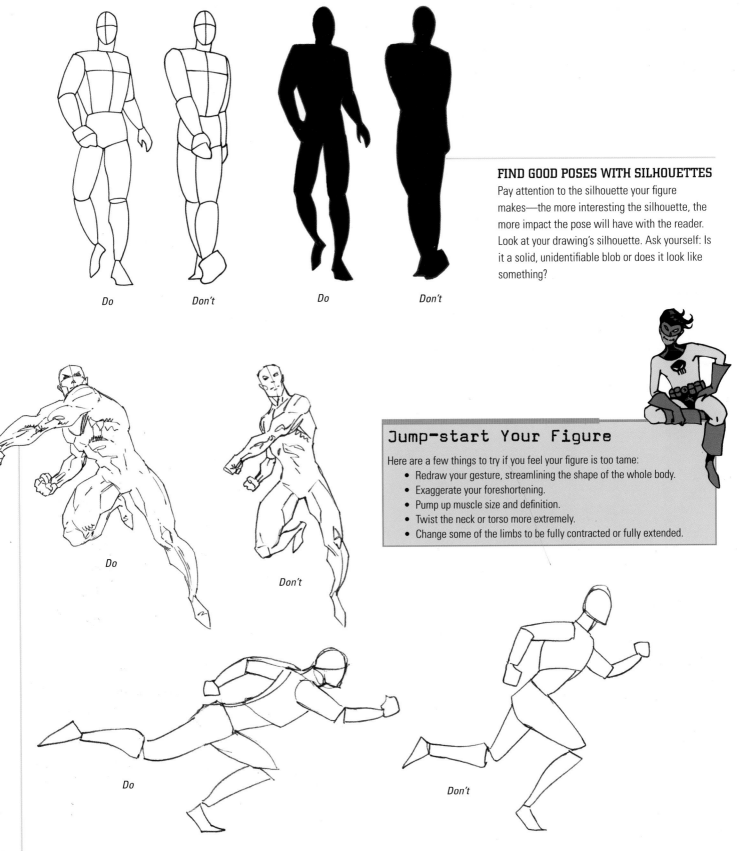

FIND GOOD POSES WITH SILHOUETTES

Pay attention to the silhouette your figure makes—the more interesting the silhouette, the more impact the pose will have with the reader. Look at your drawing's silhouette. Ask yourself: Is it a solid, unidentifiable blob or does it look like something?

Do *Don't* *Do* *Don't*

Jump-start Your Figure

Here are a few things to try if you feel your figure is too tame:
- Redraw your gesture, streamlining the shape of the whole body.
- Exaggerate your foreshortening.
- Pump up muscle size and definition.
- Twist the neck or torso more extremely.
- Change some of the limbs to be fully contracted or fully extended.

Do *Don't*

Do *Don't*

ENERGIZE YOUR POSES

Your poses should also be more dynamic. Push your figure until it is expressing the highest level of energy and motion. Notice how a few changes can make them seem stronger or faster. I repositioned the figure to create more fluid directions. I also moved the limbs and twisted the body into more extreme positions.

Now here's something cool that will make your characters jump right off the page. Foreshortening involves drawing objects that seem to be coming right at you. The basic rule is to draw closer objects larger so they appear to come forward, and draw objects smaller that are farther away so they appear to recede. This gives your figure the illusion of depth.

FORESHORTENED PLAN

For those of you who don't know him, Jack Kirby pretty much created superhero comics. One of his specialties was foreshortening figures in a very dynamic way. The lines on the figure above show you the direction of the body shapes.

FINISHED SKETCH

With foreshortening, forms change shape drastically. For instance, we see the thigh of both legs, but their position in space creates two entirely different forms.

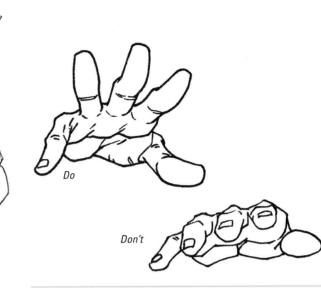

Do

Don't

REGULAR FORESHORTENING

When the figure is foreshortened, shapes overlap and some parts of the body become hidden. The figure flying away from you has this overlapping on his left arm and right leg, also his waist is obscured by the lower half of his body. The figure coming toward you has part of his torso hidden. Notice how there's a jump in size between the shoulders and legs. This helps with the illusion of something being between them.

EXTREME FORESHORTENING

With extreme foreshortening the trick is to present enough information so the viewer believes what they're looking at. Avoid angles that are too straight on because they can create tangents that contradict the illusion of depth. The hand on the right is accurate, but less effective because the fingers are creating tangents.

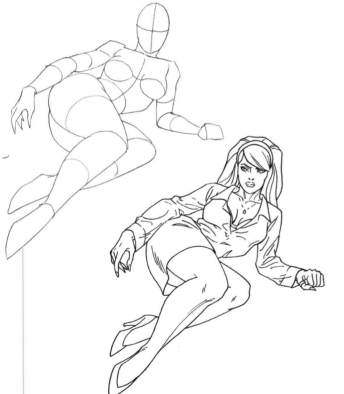

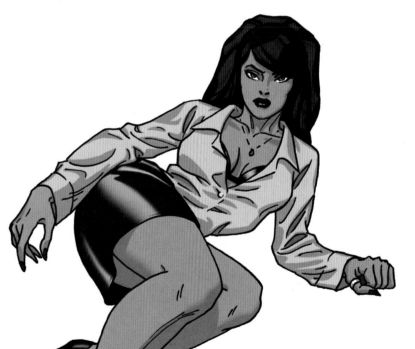

BE BOLD

It's amazing how severe you need to make your foreshortening sometimes to get the desired effect. Look at this structural drawing for the woman. It looks pretty bizarre when it is broken down into shapes.

BRING IT TOGETHER

In the final illustration it comes together and makes sense. Don't be timid or subtle with foreshortening. Be ready to make some bold changes to the figure.

I like to find new ways of redefining heroes, something more than just a guy in tights patrolling the city. For this character I was thinking about these qualities:

- A prisoner of his costume

- Haunted by his past

- Mysterious

- Highly skilled

- Possibly a cyborg

- Has his own code of morality

- A loner even if he's in a group

- Driven, to the point of obsession

1 Draw a Basic Male Figure

Start with a basic male figure. Nothing too fancy, just something to hang the costume on. Keep copies of such figures and use them like templates, so you can focus on just the costume design.

2 Create the Costume

Next, block in the costume with simple shapes. Echo the hero's anatomy with this suit by segmenting certain parts to look like muscle shapes. Try to have common elements in the arms and legs to tie the design together. This character is somewhat dark in nature, but he is a hero, so I look for ways to make him look a little bit noble. I gave him broad shoulders, wing shapes on his helmet and trademark superhero briefs.

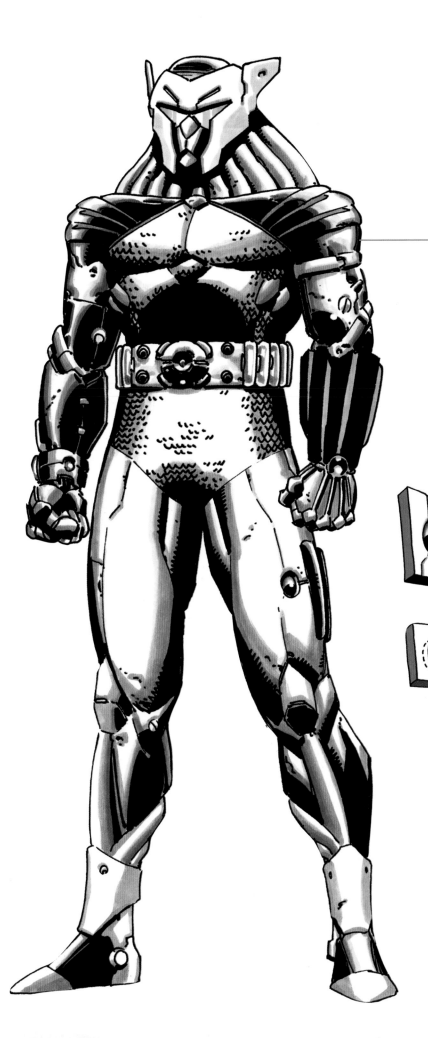

3 Detail the Costume

Give his costume a cool tactile quality by making it look like it's made from thick, rubbery material. For the rubber texture on his arms and legs, I thought about how rubber has a certain reflective quality while other objects and the ground show up as solid black. I also added dimples and gouges in the surface to imply a soft texture. Add mail armor on the torso to create a different texture. Using elements like chain mail taps in the visual language of comics and can sometimes make your design more interesting and memorable. Captain America's shirt or Namor's trunks, these are examples from superheroes that people can recognize.

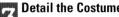

Remember to think of shapes in three dimensions. This sensor device, on his leg, is a simple cylinder-shaped hole with a curved lens dropped inside.

I thought for this character it would be fun to come up with an antihero. For those of you who aren't familiar with this term, it's a main character who crosses the line between good and bad. Here's what I was thinking of for her:

- Alien world mercenary

- Doesn't trust anyone

- Tough as nails

- Always one step ahead; she's a good strategist

- Has a lot of hi-tech gadgets but uses a sword

- Has a hip sense of style but doesn't work at it

Create Color Sketches

For color sketches, make a copy of your final marker drawing. Then use toner-compatible color markers to color it. You can find color markers that don't dissolve copier toner in art stores or art catalogs. This is a great process because the copier gives you nice, rich blacks and your coloring won't make the toner bleed.

1 Draw a Basic Female Figure
I wanted her to have a muscular, yet sexy body type. Set up that impression by making broad shoulders and hips.

2 Create the Costume
Her costume is mostly skintight so add an interesting contrast by creating a few bulky accessories. The cape adds an extra dimension to her costume and it will be a fun, big shape to play with when she's drawn in a story.

This is a common type of draping for comics. You'll find this very useful for superhero capes. Basically, it's a series of cone shapes, only the bottom edge is a connected "S"-shaped line.

3 **Add Final Details**
To achieve her special sex appeal, accentuate her eyes and stomach, then show muscle definition only in the arms and legs. The veil adds a mysterious, exotic and feminine quality—it also highlights her eyes. Give her a belt to call attention to her hips. Since she's a gritty, nocturnal sort of character, I thought her cape should reflect that. Give it a ripped, tattered edge and also lots of thin lines to make it seem like a thin, wispy material.

It's said that a hero is only as inter-esting as his villain, so it's up to you to make the guys we love to hate look good.

In this demonstration you are creating an ancient, rotten-to-the-core sorcerer. This guy is just plain evil, consumed by his own black magic. His body is de-formed and slightly mutated to reflect his dark soul. He's wearing religious garments or robes, which give him a strong, vertical direction.

1 Alter Basic Body Proportions
Start with a basic body form, but alter the proportions to make him creepy and deformed. Give him square shoulders, a small head, a thin body and long arms.

2 Design Robe and Body Details
Give his robe long, vertical lines and then flare it at the top to give him a monolithic appearance. Add some mysterious-looking talismans and charms to accent his costume.

I thought of human organs and root shapes for his chest detail.

These break down simply as a series of cylinder shapes.

When rendering shapes like this, don't do a complete outline. For the top edge, which usually gets the strongest light, make your lines thin, broken or not there at all. Put your strong lines and shading on the bottom edge of the shape to make it pop out and look three-dimensional.

3 Add Final Details

Embellish the dark sorcerer look by obscuring what is cloth and what is flesh in some areas. For really evil facial features, make his eyes and mouth look like slits cut into his head. I put the holes in his head to make it seem like he's a husk with energy inside. It also seemed like a good alternative to devil horns.

Let's do a bad girl with a hard body—literally. She's a cyborg with attitude and a big gun. The only human part of her left is her brain. She's actually older than she looks, too, most likely a veteran from the Cold War. Now she's a freelance agent, a deadly combination of experience, power and ruthlessness.

1 Draw a Basic Female Body
Start off with a generic female body shape.

2 Create the Costume
Start adding shapes to form her costume. Mostly it's a matter of how the garments cut her figure, since they're all skintight. I want her to look sassy, so that's what I aim for when I develop her hair.

She's a villain with an aggressive personality, so I thought it would be cool to have someone with a synthetic body present themselves in a sexy sort of way. She might even have a sense of touch and be able to regulate how much she feels.

Sometimes in a story, a character will undergo a drastic change in appearance. For example, say this cyborg gets her face ripped off or she falls in a vat of chemicals and loses her skin. If it's an important change revealing something you'll see in more than one panel, you should develop her interior design.

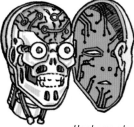

Her human brain is encased in her head.

Her robotic armature looks similar to a skeleton. It's designed to be a simple yet powerful mechanism.

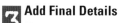

3 Add Final Details

Her outer structure is a soft rubber-like material. I made it a beige color because she's not trying to blend in and pass for being human. She's proud of what she is and loves working as a mercenary spy. She's very professional, but she's not doing it for the money.

Her clothes make her look like a super spy. They're tight, leather and wildly colored—something appropriate only for international espionage.

efore you start drawing, come up with ideas about what your robot does. When I create robots, I get inspiration from anime and manga. Japanese artists have incredible concepts and details for mechanical subjects. Keep in mind that your design needs to function and look good if drawn in various poses and from different angles. It may look like a cool design, but if the character can't lift his arms, that's a major flaw.

1 Create Body Shape
Start with a basic body shape, as shown on the left side. For this robot, use human anatomy as a guide for much of its form. After you get the basic body shape, develop it into simple muscle shapes. It's a robot so I'm rearranging some of the proportions. For instance, I pushed his head down and increased the scale of his arms and chest. This gives him more of a hulking, ape-like quality.

Joint Function
Although robots are devised from your imagination, it's important to make the reader believe that this robot could actually function. Mostly this applies to joints. Their mechanism for bending or turning needs to make sense or at least needs to give the illusion of working correctly.

2 Add Structure and Character
On the body frame, hang the shapes to construct the various added details. Notice how you can make the boot on the right more complex by just adding a few smaller shapes. Most of what you're doing is just making a simple shape and then subdividing that into different smaller shapes. For example, notice the development of the shoulder and forearm. It's important to develop your drawing this way because it gives your shapes a strong foundation.

Chrome is a highly reflective surface. The form of a curved chrome surface is revealed with fluid groups of lines. Use these examples to guide you if you would like to create this effect.

3 Add Final Details

Now that you have a good foundation for your design, go crazy and add all the cool details you like. You can use cables and wires to make a neck treatment. When creating your robots, keep in mind the possibilities of adding different textures and surface qualities. Experiment with creating reflective chrome, rusty metal, soft rubber or shiny glass.

Combine Materials

Have fun with robots. They can be any size, shape, color or style. Try combining different materials too; metals, plastics, glass, rubber, cloth. It's a great subject to show your creativity.

reating cool gadgets relies on a balance between function and design. Keep in mind how a gadget looks; its appearance should indicate something about its function. For example, I used a segmented design for the telescoping weapon below. However, don't let yourself get too carried away with function. Remember that it needs to look cool, too. Play up the design. Look for ways to give it style.

This telescoping device takes the weapon ideal a little further by having other purposes, such as sensors for spying and a computer brain that makes it like a separate little character. It has sort of an insect-looking face for that reason. The knife blades up front are retractable. That gives it an extra dimension because it can change its appearance.

Have your character's knuckles shoot lasers or some kind of energy blaster. This device creates a unique shape for the knuckles.

A PROCESS FOR CREATING A DEVICE

I need a weapon for my character named Tech. Here's what I know about her.

- She's a gear head
- Builds and fixes race cars
- Good at making things
- Too smart and in control to use lethal force
- Her prosthetic arm is very strong
- Lives in the future

Based on her information, I put together ideas for how it should look.

- It sprays a knock-out gas, but she thinks ahead so it has a tazer device in case she needs a backup.
- It looks jury-rigged, not manufactured, like something put together from spare parts.
- The design is somewhat asymmetrical because it has been slapped together.
- It shouldn't look like a weapon; more like one of her shop tools.
- I want it to look a little like an air tank, to relate to the gas function.
- The tazer has an added-on look.

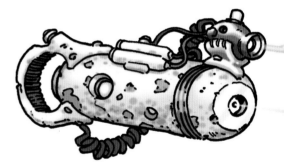

THE FINAL DEVICE

Thinking about all those things, here's what I came up with. It's crusty and could be mistaken for one of her shop tools. I made the tazer look very different so it stands out. I used some spots of color so the device relates to Tech's appearance. The wires indicate an electrical function. I also thought about how things would look different in the future. For this, I gave some parts a more unique shape, like the handle, the tazer, and the band around the tank. Here, you can see how I used simple shapes to first get the structure right. From this point it was just a matter of assembling shapes and details that fit in with my ideas.

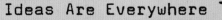

Ideas Are Everywhere

Get ideas for your devices and weapons by looking at many different examples of man-made objects as well as things in nature. Insects have great elements of shape, color and pattern.

ometimes you just can't draw every-thing from your head. This is when you need reference material. Start off by collecting books or magazines on general subjects, such as weapons catalogs, visual dictionaries, clothing catalogs, muscle magazines, anatomy books, automobile magazines and city picture books. When you need something specific or specialized you can use the Internet or find a magazine, but resist the urge to buy too many books because it can get costly. That leads me to my next point—don't be a slave to reference. You can waste a lot of time hunting for the right image.

The best way to work, as you can see in the next three examples, is to first draw something as well as you can and then find references to help complete your image.

IMAGES; www.freeimages.co.uk

IMAGES; www.freeimages.co.uk

IMAGES; www.freeimages.co.uk

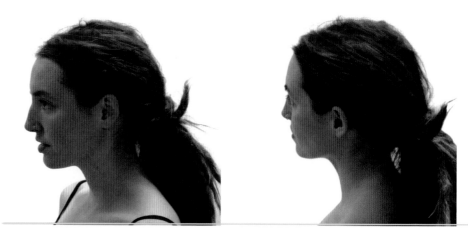

Sometimes you may find the need to use a model for a character. I do it often to prevent myself from drawing the same features. Some artists go to the extent of creating costumes and precise poses, but that can be a lot of work and expense. A simpler way is to find photos in magazines or catalogs. It could even be just one image that inspires you to create your character. You could also take pictures of friends or family and use those.

For my example, I took several pictures of a girl who had an interesting, old world quality. Her features looked like someone who could have come from ancient Greece.

I then made sketches from the photos, developing her into a warrior character. Here are some of the ideas I had about her personality: She's adventurous, at home on the sea; a leader at times; a bit of an outlaw; she can be tenacious and easygoing, unless crossed; a traveler, worldly for her time period.

I really liked the way her dreadlocks gave her a unique look, so I played that up to create a cool hair shape. I thought it also played in with the character's wayfaring lifestyle.

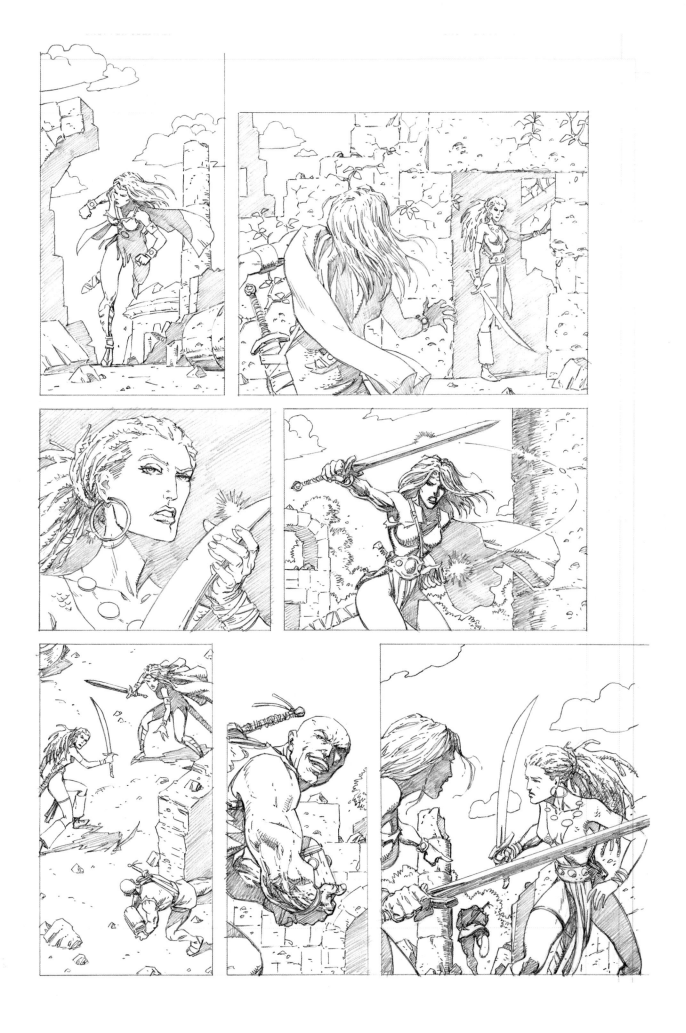

There's no room in comics for your everyday backyard friend. Animals need to be drawn bigger than life. So, it's up to you to really energize them. In the examples below, the one on the left is a decently rendered animal with nothing wrong with it—except it's dull. The version on the right is much more dynamic.

FIND THE BEST MODEL

Choose the best example for a particular animal. For example, there are many types of snakes; pick the one that really makes you cringe, then exaggerate its features. If it's still not enough, mix and match different traits, or exaggerate their features more.

CHOOSE AN ANGLE

You also need to know how to present your creature. Think about the angle you're viewing it from. Does it give you the effect you want? Using an angle looking up at your creature is a great way to make it more dynamic.

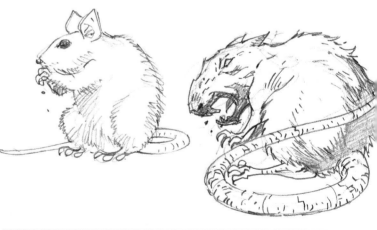

STRIKE A POSE

Posing is the real trick. On the left, you have a dull straight-on view. You need to create interest. On the right I use a ¾ view. I also tilt his head up so he's looking down at us in a dominant way. Notice how overlapping and foreshortening things creates depth. Pay attention to your silhouette too, and check to make sure that it has enough interest. The left silhouette looks like a blob. The right silhouette is much more active.

ENHANCE SURFACE DETAIL

Look for ways to make the surface detail work better. Exaggerate the texture or give more character to the fur. Notice how I stylized the rat's tail to make it more menacing.

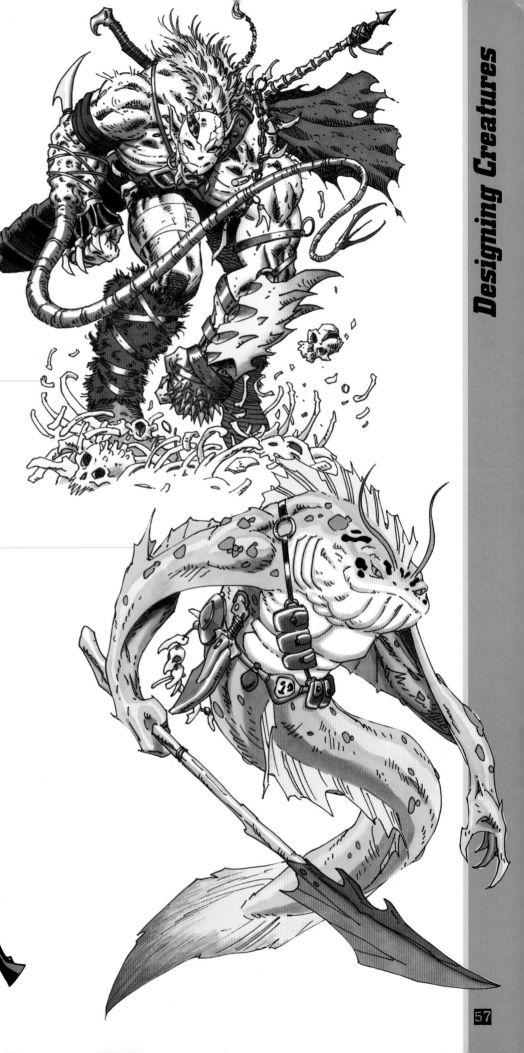

aking up creatures is a lot of fun and it allows you to be creative. But you need to find your inner creature first. Think about these things before starting:

- What does your story say about the creature's purpose and needs?

- What impression do you want to achieve?

- What qualities do you want to combine to make your creature?

- What new twist or idea can you bring to it?

MUTANT MARAUDER

For this creature I wanted to come up with something really over the top, with lots of exaggerated features. First, I made a dynamic body type. Then, I let my imagination go wild. I especially like the doll mask because it creates a creepy, dual identity for his face. For his costume, I combined various barbarian garb.

ALIEN WATER DWELLER

Here I wanted to make an alien water dweller, intelligent but warlike, with a combination of hi-tech and low-tech weaponry. I started by combing human and fish features. Then, I looked for ways to make him more dramatic; ribbon-like fins, feelers from his head, and webbed arms. To show intelligence, I gave him a belt and bandolier with complex devices. The string of bones is used to activate the space around him a little. I made his pike look like coral to tie in with his environment.

An Artist's Rendition

If you feel your design is not working or it's too tame, look at the work of artists that you feel are good at creatures. This can put things in perspective and help you to reevaluate your design.

Perspective is one of the most important tools for drawing comics. It's a formula for creating the illusion of depth. It's also the backbone for creating believable environments for your scenes. The basic principle is objects get smaller as they go back into space. Sounds simple, right? First off, there are a couple of terms you need to know before you start practicing perspective.

Horizon line: This is a line representing where the Earth meets the sky. It's also known as your "eye level."

Vanishing point: The point(s) where all receding lines meet on the horizon line.

There are three basic types of perspective: one point, two point and three point.

Space Vanishing Points Farther Apart

If the points are too close together on the horizon line, your perspective will look squashed and distorted. Experiment with spacing them farther out to find what looks best.

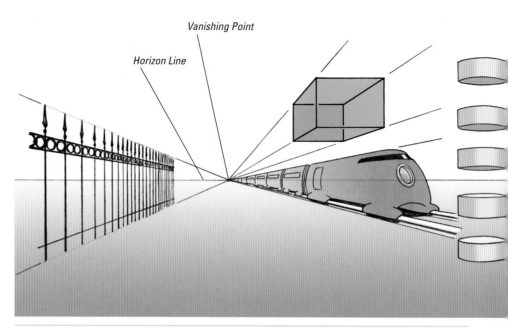

Vanishing Point

Horizon Line

ONE-POINT PERSPECTIVE

This is when all parallel horizontal lines that are going back in space converge on a single vanishing point on the horizon line. Notice the vertical bars of the fence as they go back in space. They get smaller and closer together. The same thing also happens with the train cars. In comics, one-point perspective is mostly used when your view is squarely centered in relation to your surroundings. For instance, if your view is looking down the middle of a street.

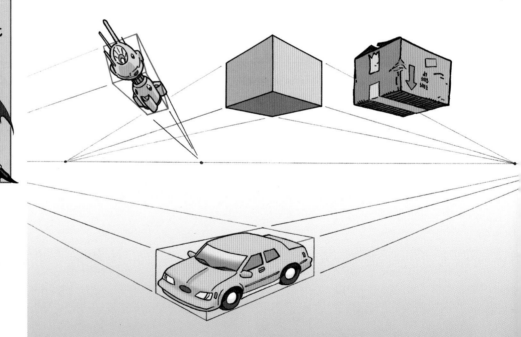

TWO-POINT PERSPECTIVE

This is when objects or settings have no face parallel to the picture plane and their horizontal lines recede to two vanishing points on the horizon line. If you have multiple objects in the same scene, each will have its own set of vanishing points. Sometimes the points coincide and sometimes they don't. Here the spaceship and car are in the same scene, and they each have their own set of vanishing points. The receding lines above the horizon line slant down to a vanishing point while the receding lines below the horizon line slant up to the vanishing point. The cube shows how the cardboard box was formed. It also illustrates that perspective is a structural tool. Notice how much character you can add even to something as simple as a box.

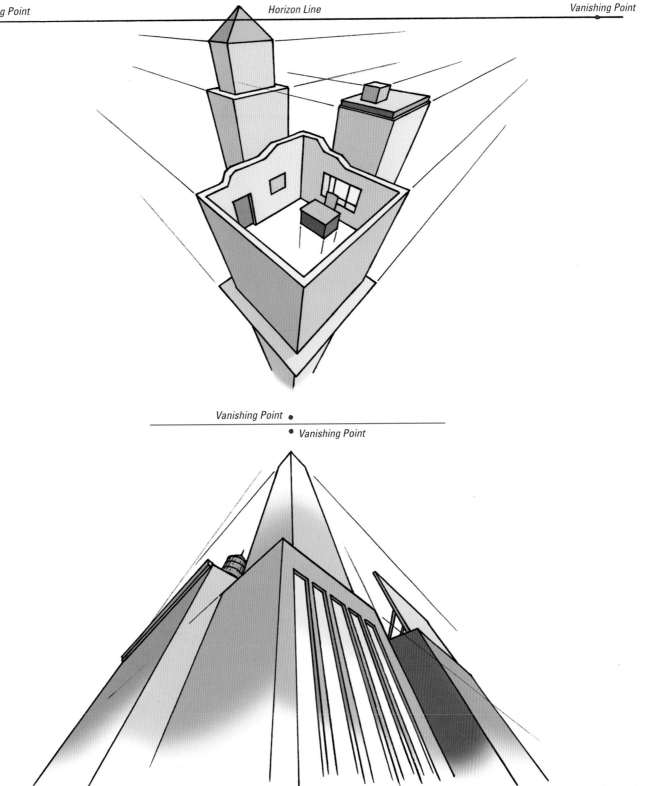

Vanishing Point

Vanishing Point

Vanishing Point

Vanishing Point

Horizon Line

Vanishing Point

THREE-POINT PERSPECTIVE

This is the same as two-point perspective, only now you have another point off the horizon line, either above or below it. Where you place it is up to you. Three-point perspective is primarily used for views looking down or up at things. An upward view is great because it can make things like buildings or people grander and more dynamic. See "Worm's Eye View," on page 61, for more about this.

OK, now let's snap perspective into action. Notice the small diagrams showing where my vanishing points (the red dots) are in relation to the panels (the blue frames). With these you can see the vanishing points and horizon lines when they're off the image.

ONE-POINT PERSPECTIVE

One-point perspective is a standard and you'll be using quite a bit. Possible uses could be looking down a city street or tunnel. Here I used it for a long view of a cityscape. Notice how as things go back in space they lose detail, so the farthest things should be outlines or silhouettes.

TWO-POINT PERSPECTIVE

Two-point perspective is more complex but will also make your image more complex. That's a good because it creates something more exciting for the reader. I've tilted the horizon line here to create a more dynamic view; also, putting it in a vertical panel gives it that feeling of dizzying height.

HORIZON LINE

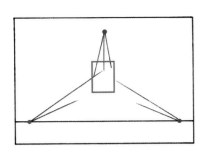

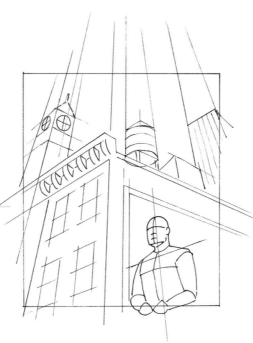

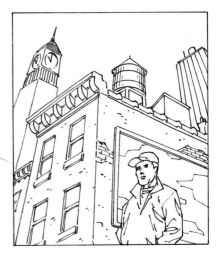

THREE-POINT PERSPECTIVE—A WORM'S EYE VIEW

This is a great way to make figures and buildings more dynamic. Looking up at things gives them a monumental quality. In this example, its use makes the man seem insignificant or downtrodden.

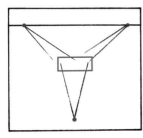

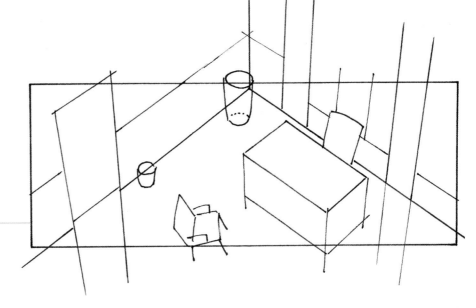

THREE-POINT PERSPECTIVE—A BIRD'S EYE VIEW

This is a great view because it's an angle that effectively shows a character in relation to his setting. Notice the chair in front of the desk. It uses the same third point below but has two new points on the horizon because it is turned.

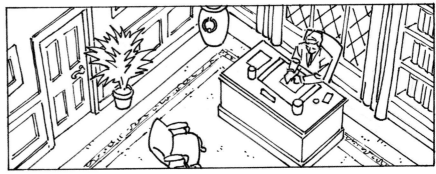

Polish With Perspective

My first step with all of these scenes was to first lightly sketch what I imagined in my head. Then, when it looked like the view I wanted, I used the correct perspective.

Think about your set designs before starting any page art. It doesn't have to be detailed; just create a floor plan or something showing the mood or atmosphere of an environment.

First, determine what impression you want your setting to convey. Is it pleasant, scary, claustrophobic or romantic? Next, begin associating elements that express your setting. It helps to think of settings as characters. Here are some ideas for giving them their own personality:

- Create a focal point, an area that attracts your eye.

- Use props that enhance the setting and with which people immediately identify.

- Patterns: checkerboard, stripes, polka dots, etc. are also effective. They're designs that people identify with immediately.

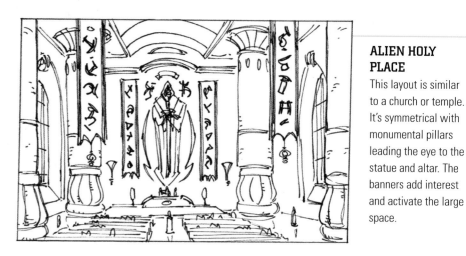

ALIEN HOLY PLACE

This layout is similar to a church or temple. It's symmetrical with monumental pillars leading the eye to the statue and altar. The banners add interest and activate the large space.

SEEDY HOTEL ROOM

I wanted this to feel small and rundown—a real dump. The furniture is dull and mismatched. The numerous props make it seem smaller. It's fun to invent little details, like a hole in the floor with a board over it. The sign outside the window is a setup for some moody lighting.

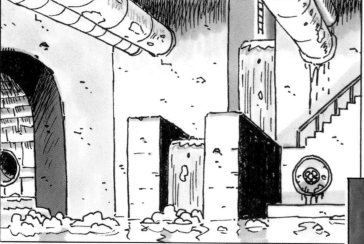

SEWER

This large, cavernous space has thick, blocky structures that work as good places for characters to interact. I imagined there being old stone block tunnels along with the newer cement structures.

ALIEN CITY

For the architecture, I thought of sculptural shapes, as well as toys and jewelry. The architects are aliens, so the design and construction reflects this. These buildings are obviously not from Earth.

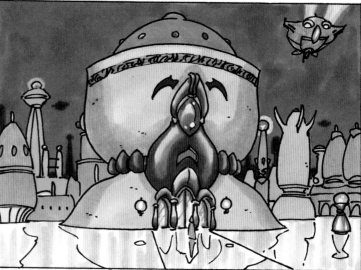

Many beginning artists are concerned about developing a drawing style. I'll highlight a few comic styles to give you an idea of the possible directions to develop your work. Different drawing styles are like acting and directing in movies: In film you have various themes (serious, light, realistic, fantasy, etc.); in comics you can express these themes with your style of art. Think about what types of comics or films you like the most, then develop your drawing style by combining elements which fit that style.

Realistic

WHAT YOU LIKE

- *Film:* Independent productions, period films, dramas
- *Comics:* Vertigo books, European comics

ELEMENTS FOR ART

- *Style:* Realistic or expressive
- *Figures:* Normal proportions, use photo references, subtle posing (less contrived), contemporary or period clothing
- *Backgrounds:* Real world, gritty reality
- *Inking:* Less stylized, lots of black areas and shadows

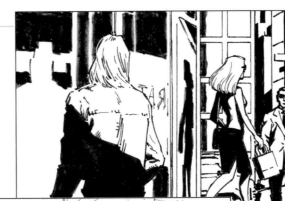

COMPLEXITY

For this style, capture the chaos of the real world, like this scene. Use reflections, realistic lighting, complex backgrounds, loss of detail in the distance.

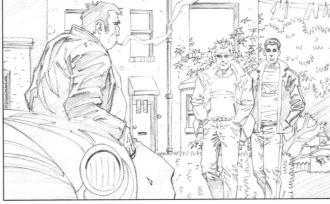

THE UGLY

Ugly people, ugly clothes, ugly places. For more reality, get in touch with the ugly things in life.

GET HIP

If your story takes place in the present day, make sure your character's clothing is up-to-date too. For help, look in magazines or check out people at the mall.

For each style, I'll draw this character so you can compare the differences. Here, notice his realistic proportions and the gritty linework.

Super Dynamic

There's quite a range for this style. It can be a little dynamic, or you can cut loose and do an "over the top" approach.

WHAT YOU LIKE:

- *Film:* Action adventure, fantasy, sci-fi, martial arts

- *Comics:* Image, Cliffhanger, Wildstorm, Top Cow

ELEMENTS FOR ART:

- *Style:* Dynamic, high energy, anime (Japanese animation) influences (especially robots, gadgets and devices)

- *Figures:* Exaggerated anatomy, extreme foreshortening, high-energy poses, contemporary clothing

- *Backgrounds:* Stylized versions of reality, archetypes

- *Inking:* Slick, stylized, detailed, some use of blacks but also a lot of line-work like crosshatching and gradation effects (see Chapter Four for examples)

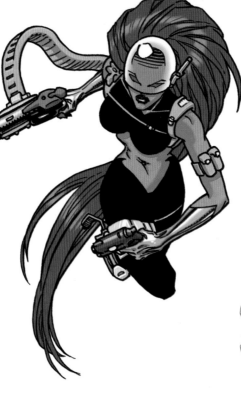

POP IT
Use foreshortening to make the characters come right off the page.

OVER THE TOP
One variation of this style is to pump energy into everything, especially figures. Exaggerate muscles, costumes and weapons. Go wild.

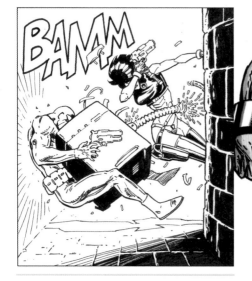

IMAGE
This shows qualities of an Image style. The inking is slick and technical, with an emphasis on linework. The posing is dynamic, high energy. There's also a lot of attention to drawing in details.

Heres the same character again. This time notice the exaggerations to his body, costume and pose. The inking is stylized and more technical.

Anime Fusion

This anime style has been growing in American comics. If you don't know, anime is Japanese animation. It's a fun, high-energy drawing style. You can't help getting inspired after watching some anime features. Another aspect of this style is a strong use of design in almost every aspect.

WHAT YOU LIKE:

- *Film:* Action adventure, sci-fi, fantasy, horror, comedy, martial arts, anime

- *Comics:* Manga (Japanese comics), American anime-style comic art

ELEMENTS FOR ART:

- *Style:* As varied as anime, cartoonish to realistic

- *Figures:* Exaggerated and stylized proportions, larger eyes

- *Backgrounds:* Highly-stylized and designed

- *Inking:* A fusion of anime, manga and American techniques, including speed lines and clean, yet expressive linework

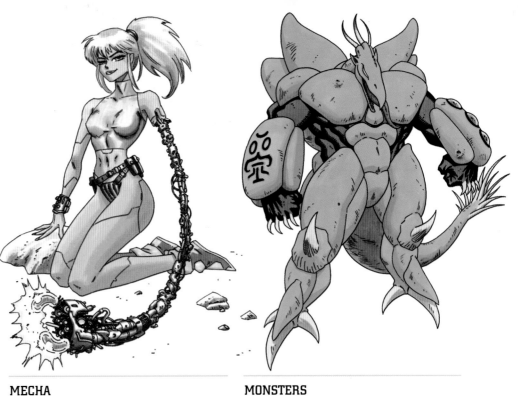

MECHA

If you like cyborgs and robots, this is the style for you. Anime is all about drawing cool gadgets and devices. Especially combined with the human form like this.

MONSTERS

Anime creatures need to be well thought out. It requires their concept to be interwoven with their design and powers. This character is a demon based on dinosaurs. One of his abilities is to reanimate the spirit and also the fossilized bones of the dinosaurs.

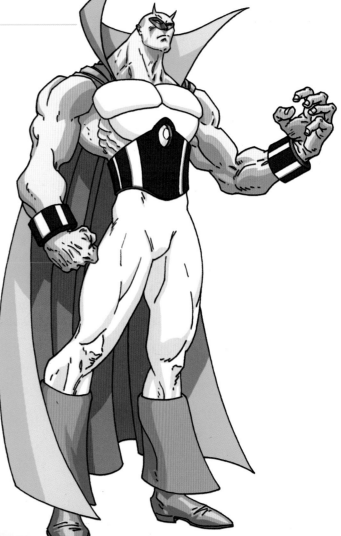

Here's my hero again. Notice how exaggerated the proportions can be. This also illustrates a style of anime that uses almost all linework. Color is used to create all the shaping and the lines are an even thickness.

CARTOONY

Anime also has a wide range of cartoonish styles. These are usually for humorous stories. It's high energy and involves a lot of exaggeration.

STORYTELLING

Conveying a story through pictures is one of the most important parts of drawing a comic book. Like the director of a film, you communicate with the visual language of camera shots to create the right pacing and emphasis. In this chapter, I'll show you how to direct the reader through the story using camera angles, composition and panel layout. Don't worry, the technical information is actually pretty minimal.

Anime Fusion

This anime style has been growing in American comics. If you don't know, anime is Japanese animation. It's a fun, high-energy drawing style. You can't help getting inspired after watching some anime features. Another aspect of this style is a strong use of design in almost every aspect.

WHAT YOU LIKE:

- *Film:* Action adventure, sci-fi, fantasy, horror, comedy, martial arts, anime
- *Comics:* Manga (Japanese comics), American anime-style comic art

ELEMENTS FOR ART:

- *Style:* As varied as anime, cartoonish to realistic
- *Figures:* Exaggerated and stylized proportions, larger eyes
- *Backgrounds:* Highly-stylized and designed
- *Inking:* A fusion of anime, manga and American techniques, including speed lines and clean, yet expressive linework

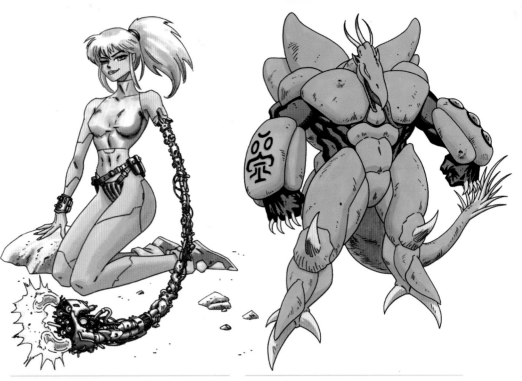

MECHA

If you like cyborgs and robots, this is the style for you. Anime is all about drawing cool gadgets and devices. Especially combined with the human form like this.

MONSTERS

Anime creatures need to be well thought out. It requires their concept to be interwoven with their design and powers. This character is a demon based on dinosaurs. One of his abilities is to reanimate the spirit and also the fossilized bones of the dinosaurs.

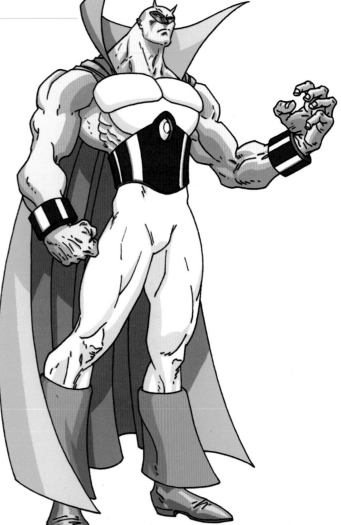

Here's my hero again. Notice how exaggerated the proportions can be. This also illustrates a style of anime that uses almost all linework. Color is used to create all the shaping and the lines are an even thickness.

CARTOONY

Anime also has a wide range of cartoonish styles. These are usually for humorous stories. It's high energy and involves a lot of exaggeration.

STORYTELLING

Conveying a story through pictures is one of the most important parts of drawing a comic book. Like the director of a film, you communicate with the visual language of camera shots to create the right pacing and emphasis. In this chapter, I'll show you how to direct the reader through the story using camera angles, composition and panel layout. Don't worry, the technical information is actually pretty minimal.

Pacing is the rate at which you show the story. It's also how you control the suspense and mood of a scene. Keep in mind how fast the reader is moving along. One of the most important aspects of pacing is how much story information you put in your panels.

The amount of dialogue or visual information can change your pacing, too. The more there is, the slower it becomes. You can also affect pacing with the size, number and shape of your panels. With so many different factors, it really depends on the combination you use and what results you get.

Something that helps me with pacing is to imagine the panels as rhythmic beats. For instance, a loud beat would be a big panel; a few even beats, a series of panels; intensifying beats, a series building to a climax. As you are imagining or tapping out the rhythm, think about how it relates to the mood of the scene, like the soundtrack of a film.

Here is the same scene paced two different ways.

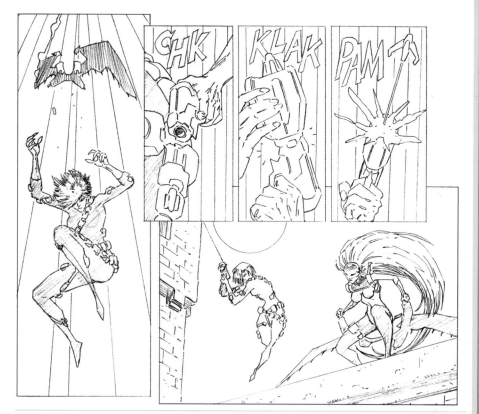

VERSION 1

This version breaks down the character's action, assembling a device, into a series of panels. Her actions are drawn out, which slows the pace of the panel sequence. Notice that I also used three panels of identical size and shape for this series. That's so they will be read as a unit.

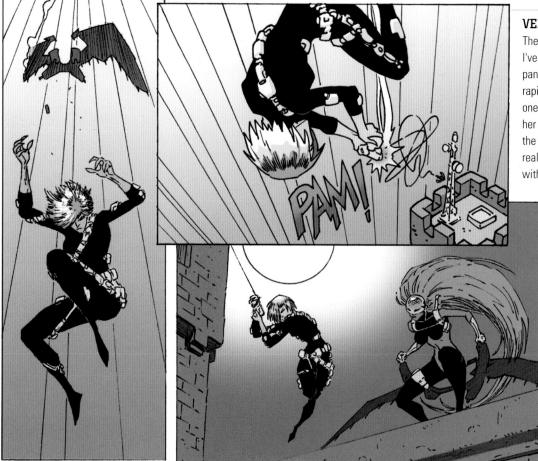

VERSION 2

The pacing is faster here because I've condensed her action into one panel. This version creates a more rapid and fluid sequence. However, one change I would make is to have her reaching for one of her devices in the first panel. Neither version is really right or wrong; it all has to do with the timing you want to achieve.

Before you dive into illustrating your stories, you need to first familiarize yourself with various camera angles (or shot types). Your goal is to learn how to pick the best shot for the piece of story in your panel. First think about why that part of the story is in the comic. Then think about the impression you want it to have on the reader. These two criteria narrow your shot choices down considerably. If you're working from a script, the writer often calls for a specific shot. Notice that most of these shots refer to where the camera—or for your purposes, the viewer—is in relation to the characters.

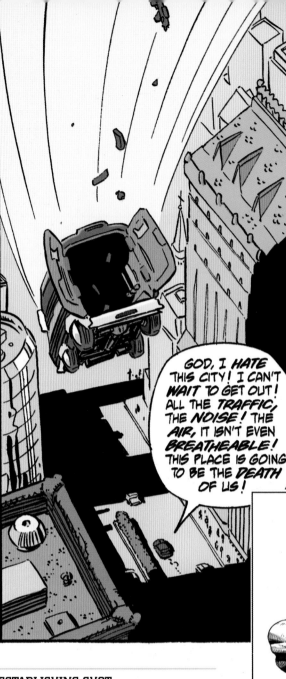

ESTABLISHING SHOT

This introduces the setting and can also show where characters are in relation to things. It's usually a long shot, but it doesn't have to be. It's often the first panel of a scene, unless you're holding back something you want to reveal later. During a long scene you should place the occasional establishing shot, as a visual reminder for the reader. Another visual cue along those lines is to include parts of the setting in almost every panel. This is a way of touching base with your establishing shot.

LONG SHOT

The view is pulled back to show more of a setting. The point of view could be twenty feet or a mile back depending on what you need to show. You could have a long shot of a sunset or a view of the universe. In this example, I used it so the reader cold clearly see what was happening and where it was happening.

MID-SHOT OR MEDIUM SHOT

This is a standard, eye-level shot. Focus it anywhere from the waist up to full figure. You commonly see examples of this type of shot in talking scenes.

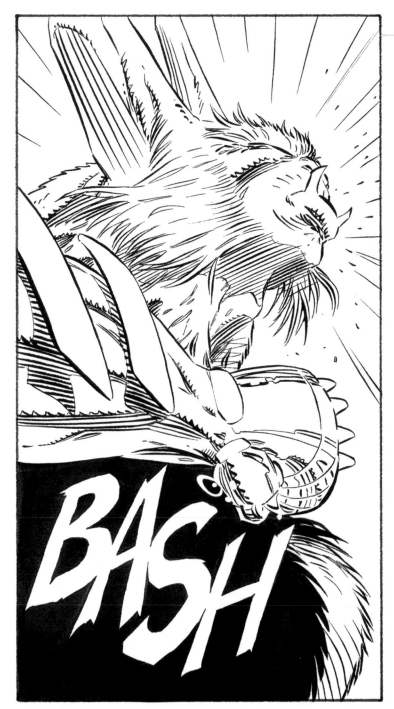

CLOSE-UP

You're focusing in on a character's head or showing something up close. It's good for building suspense or showing facial expressions.

EXTREME CLOSE-UP

This is even closer than a close-up. It could be anything from part of a hand to something microscopic. It can be used to point out something specific to the reader or as part of a sequence where the view is zooming in or out.

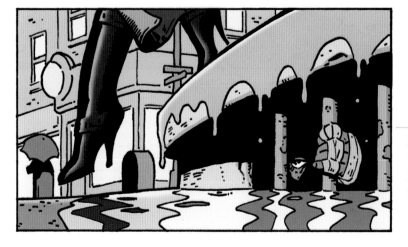

LOW ANGLE

In this shot your view is close to the ground. It reveals the figure in the drain. Other angles would not be as effective for getting the reader to feel the mood of this scene.

DOWN SHOT OR BIRD'S EYE VIEW

This view looks down at things. It's good for exiting a scene or showing characters in relation to things on the ground. It can be used to indicate defeat or self-reflection to help show a character's mood.

UP SHOT OR WORM'S EYE VIEW

This view looks up at things. It's good for making objects or scenes look more monumental; for instance, it can add power and mood to figures or buildings.

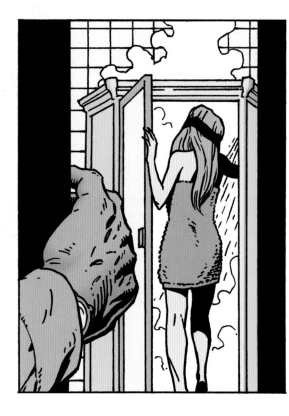

POINT OF VIEW

This is a shot of what a character is seeing though his or her eyes. This phrase is also used by writers to indicate a precise camera angle, i.e., "Point of View: Looking through the window." Often writers will indicate by writing down POV.

Reverse Angle

A reverse angle is when you use the opposite of the view from the preceding panel. The examples I have for the down shot and up shot illustrate this flipping of the view.

Once you've selected the shots, consider the composition of each. You can control how the viewer's eye moves through each panel by arranging the elements within them. When composing each panel, consider:

• The placement of figures and objects

• The angle of your view

• Where you will add areas of black

A well thought out composition makes your drawing visually stronger and gives it more impact.

OVERLAPPING OBJECTS

Notice the interplay of black and white areas. Each helps define the other, just like the Chinese symbol of Yin and Yang. In this scene, the window on the right is defined by the big shadow. The window in turn then describes the leaping cat and the trash can lid.

Yin-Yang

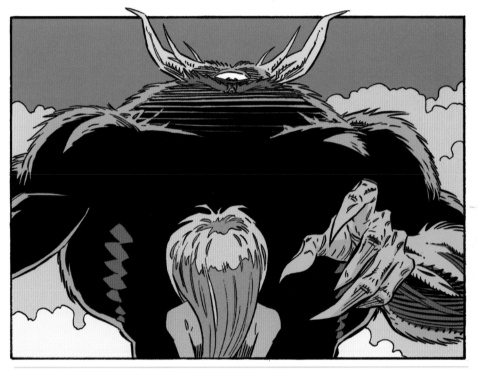

FRAMING

Here, the framing effect highlights the girl and also plays up the imposing presence of the monster, visually swallowing her form. Basically, this is using blacks to surround what you want the reader to notice.

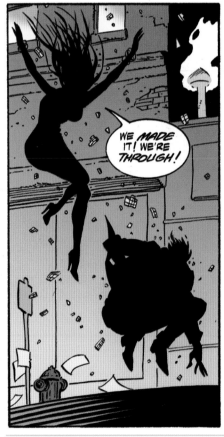

SILHOUETTES

In this shot, the silhouette immediately draws the eye to the area of interest—the figures. The other blacks work to balance the composition.

Here are some standard ways of arranging the elements within your panels. To remind you, those elements are:

- Figures
- Objects
- The view of your setting
- Areas of black

SYMMETRICAL

This is an arrangement that is split evenly, with sides that mirror each other. You wouldn't want to use this type of composition all the time, since perfect balance can get boring. It's best to save symmetrical compositions for images that have an aspect of symmetry about them. For instance, in this shot angle, the way I thought of her using her weapons suggested symmetry to me. Then I just pushed it further with her pose and other elements of the composition.

ASYMMETRICAL

This is any composition that is not symmetrical. With asymmetry, you have a much wider range of direction for the reader's eye to follow. It also creates a more complex image because it's not as predictable as a symmetrical composition. Generally, this is what you use most.

RECESSIVE DIAGONAL

In this composition, your eye is directed back in space, from foreground to background. The path you follow is a series of diagonals punctuated by elements in your image. This is a very versatile composition and it is great for giving your image depth. If you look at the example for asymmetrical composition, you'll see a recessive diagonal used there as well.

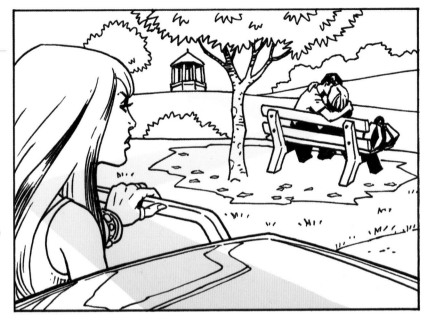

CIRCULAR

Arrange the elements in your image to direct the eye clockwise around the outside edge and then into the center. It's almost like a spiral except you don't want the eye to stop dead in the center; you want it to feed back out to circulate again. You can use this in combination with a recessive diagonal. Notice, I also used a recessive diagonal in this image .

Sometimes it's also helpful to know what not to do. Two common composition errors are awkward cropping and tangents. Let's take a closer look at these problems.

DON'T
Notice how crowded and stiff the figures look. The problem is that the arms are running parallel to the border. In most cases, avoid poses that echo the border in this way. The other problem is that these figures are too closely cropped. This creates a tension with the panel border and makes it stand out too much.

DO
With cropping, you want the reader to feel that the image extends beyond its borders so it looks like a portion of something bigger. We're showing them a part of a much larger view.

Try to avoid crowding by going in closer or pulling back further. Another thing I did was tilt the view. Instead of a straight-on view, try an up shot or down shot.

DON'T
Tangents are when separate things line up directly or touch each other, creating false connections. The problem spots are circled. Other problems with this composition is the dull, straight-on view and awkward cropping of the figure on the right.

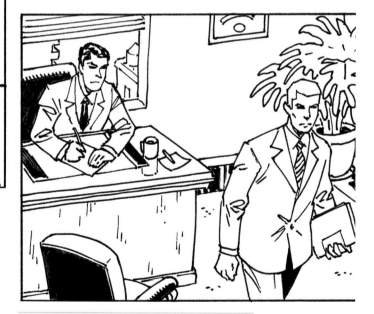

DO
The first thing I did to improve this was to change the shot angle. It created a more complex, asymmetrical composition and showed both characters well.

I also introduced more props and added some buildings outside the window to create more depth. Other improvements I made were to put in some blacks and add a few textures.

Crop Magazine Photos

A good exercise to practice cropping would be to take a magazine and crop the photos in a different way. Notice how you can change the impression of an image by cropping it differently.

Y ou've learned the basic shot types, so now it's time to learn other kinds of visual storytelling devices.

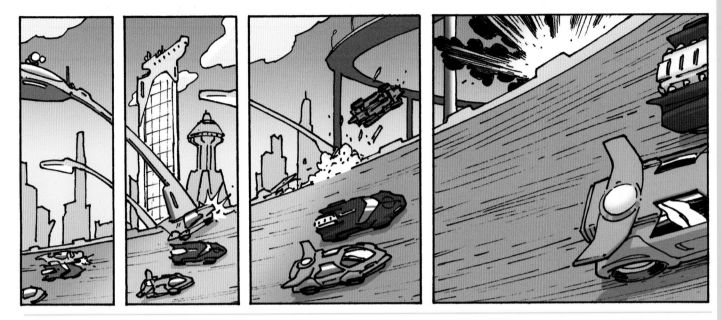

PANNING

This technique involves following a subject or showing a view that is really wide or tall. For comics, this translates into long panels or a series of panels. In this example, I use a series of panels to show a sequence of events. Together the panels show one image. They're divided so you get the impression of following the two cars across it.

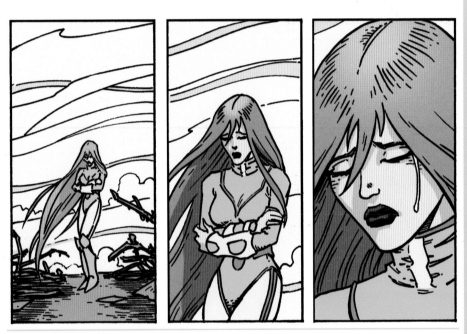

TRACKING

This method involves a series of panels where the view is zooming in or out, or the view is fixed and the subject is moving. This scene tracks in from a long shot, to a mid-shot, to a close-up. Notice that the first panel acts as an establishing shot while the next two focus in on the character's emotion. The reverse, tracking out, is a classic sequence for leaving a scene.

SUPERIMPOSED IMAGE

Here you have images from completely different views placed together. One use is to show something happening, along with someone's reaction to it. You could also use it to show an image from a character's thoughts. This example shows the character inside the giant robot. This way I get both a close-up of the character as well as a long shot of what he's doing.

FLASHBACK

This shows an image or scene from the past. Here the character, who's relating or thinking about the flashback, is superimposed into the scene. This works as a good visual transition into the flashback. For a flashback that goes on for a series of panels, you can do the same thing for the first and last panel. That way you're giving the reader a visual cue that they are rejoining real time.

INSET PANEL

This is a storytelling device where there is a panel within a panel. The inset panel can present something immediately before or after what you see in the larger panel. You can also use it as a close-up of something in the larger panel. The type of border for the inset panel is completely up to you. I like an open border because it helps separate the two panels more.

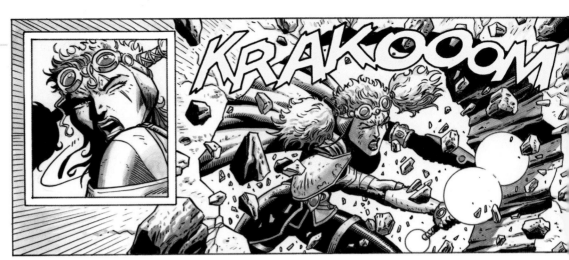

MONTAGE

This is a composition of images with different sizes and views. Often you see this used on covers. If used in a story, it's usually a full-page image. Its purpose could be a number of things: a dream, hallucination, special effect, flashback or even just a series of events, like showing the highlights of something in the story.

MULTIPLE IMAGE

This technique shows motion. For instance, you might have an action you want the reader to see but it doesn't warrant a sequence of panels. Notice that the earlier stages of his arm have color lines to make them function as ghost images. In this example the character, Redblade, is catching his weapon as it transforms from two blades to one.

Your next step is to consider how one shot relates to the others you've chosen. Keep in mind that it's good to vary angles and shots to make your panels more visually interesting. Too many panels of the same type can get monotonous. Try and feel the mood of your scene. If it's action packed, make big changes in your shot types; if it's calm, make slight changes. Here are two pages to show you some shot choices and the reasoning behind them.

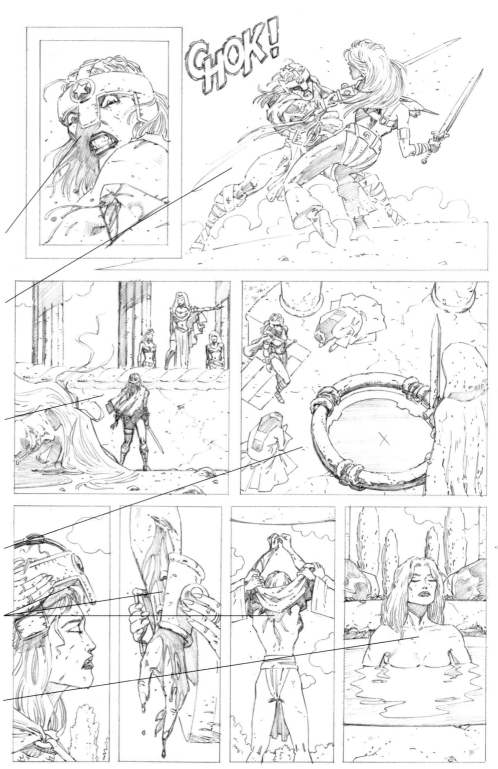

The character is reacting angrily to being wounded, so a close-up shows her reaction more intensely.

This panel pulls back into a mid-shot for the climax of the battle. It is important to show full figures so you see clearly what's occurred. The angle also faces the main character while hiding the gory details. It provides a big change from the previous shot.

This panel uses a low angle to show the defeated opponent as well as what was going on with the victor. The other option was to have a view from over the shoulder of the victor, looking up at the Queen. The low angle is better because it shows the conversation but also acts as a transition from the battle.

The down shot in this scene helps establish a new setting. It shows the most important thing—the pool and the characters in relation to it.

These panels depict a sequence of actions—the removal of the warrior's protective gear and clothing. The shots vary slightly to keep it interesting: close-up, close-up (lower angle), mid-shot.

The character descending into the pool is the most important action here. I decided to use a mid-shot to show the reader enough information about where she is specifically.

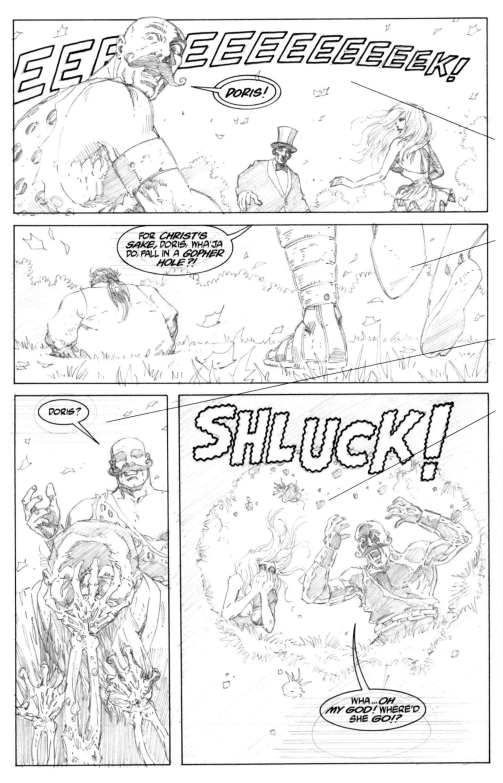

This angle shows all three characters because their reactions are the most important element. The strong man was the most affected so he stands in the foreground. The angle of the shot is slightly upward for a dramatic effect.

The characters are coming onto the scene of the bearded fat lady in a hole. A low angle gives you the best feeling for her predicament while hiding her front. What exactly is happening to her isn't revealed.

This panel reveals the bearded fat lady's situation. The close-up shot intensifies the horror. This a reverse angle from the previous panel because it reveals something to the reader.

The up shot best places your view looking up from underground. Here, you feel what's happening from the bearded fat lady's point of view.

Sit In the Director's Chair

As a good exercise, watch a video or DVD movie (something you can pause, and note the different camera shots used). Think about why the director chose those shots and what effect they have on the scene. Then carry your observations to your comics when you are choosing the types of shots to use.

How the reader's eye travels over the entire page is another area of composition. Two things influence this: 1) the images in the panels and 2) the order and shape of the panels. Both of these things work to direct the eye along a path that flows down the page from one panel to the next.

Procedure for Panel Layout

I'll take you step-by-step through the process of creating a panel layout for your page.

1. Read the script thoroughly so you understand its purpose and direction.

2. Make a list of the actions for each panel and note any shot information, (establishing shot, big panel, close-up, etc.).

- Mirata (full figure shot)

- Mirata attacks (series of panels)

- Exhausted close-up of Mirata

- Mirata > trolls (> is my notation for her to be in the foreground)

3. Sometimes it helps to do a small thumbnail sketch of just the panel layout to determine size and placement and work out the bugs.

4. On 8 ½" × 11" (22cm × 28cm) paper, working the same dimensions as a printed comic, sketch your panel arrangement. Then begin finalizing choices for your shots and sketch them in.

SCRIPT

In this story, the girl, Mirata, is fighting trolls that regenerate and multiply when killed.

PANEL 1 Mirata : REALLY, GREENSKIN?
Mirata : LET'S SEE JUST HOW FAR WE CAN PUSH YOUR LITTLE GIM-MICK!

PANELS 2-7
Mirata hacks away at the trolls.

PANEL 8 Exhausted, she rests, having dispatched the four trolls.
Mirata: HUFF! HUFF! D.. DID IT WORK THIS TIME?

PANEL 9 She turns to now to find the trolls regenerating once again, only now they are much smaller.
Mirata: @#$%^&!!! WELL... AT LEAST THEY'RE GETTING SMALLER...

Study Layouts

Panel layouts can be reserved or wild. Check out various artists to see how they approach layouts. Some are very creative with their designs.

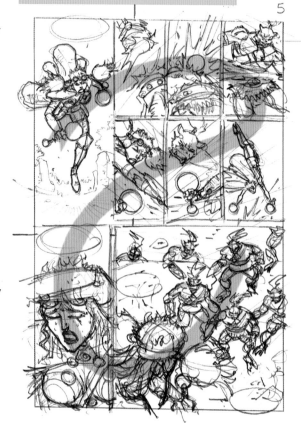

5

GO WITH THE FLOW

Here you can see how the images in the panels direct the eye over the page. Sometimes it's a strong direction and sometimes it's more subtle. Mostly you use key objects or directions to draw the reader's eye along. For example, in the eighth panel, the reader's eye moves down the center of her face. In other places, notice how the path tracks along the images like stepping stones.

Panel Order

One thing you don't want is the reader to be confused about the order of the panels. The basic rule is that panels read in order of left to right and then top to bottom.

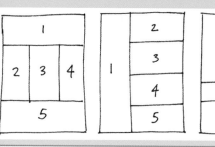

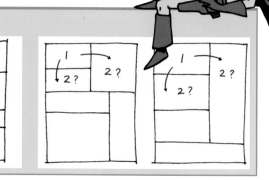

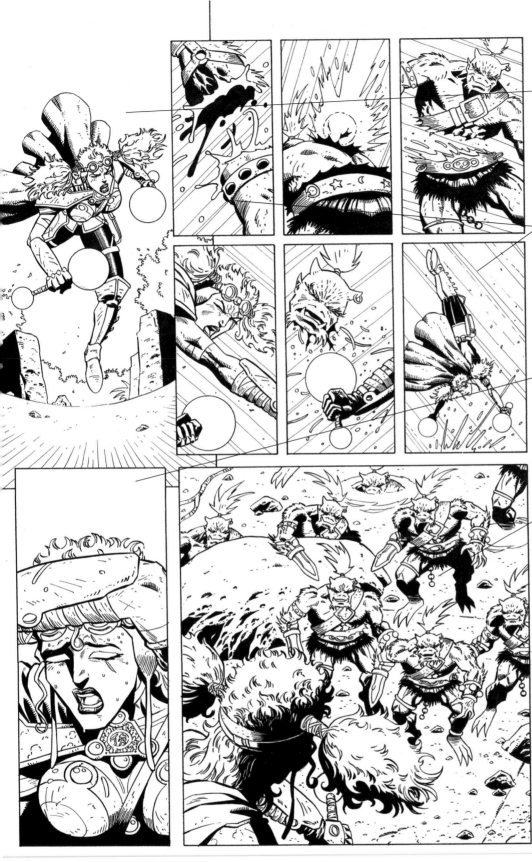

Mirata attacks

A big, dynamic, full-figure shot of the character coming right at you. Bleed it off the panel to make it bigger and less confined. Notice the direction of the figure. She's heading at you but slightly to the right. This leads the reader toward the next panel.

Mirata hacks away at the trolls

This group is a series of various shot types in small panels to be read as a unit. Using the same size panels for the whole sequence makes it feel like a quick succession of actions. Overlapping the previous panel creates a layering affect.

Exhausted, Mirata rests, having dispatched the four trolls.

In this close-up, I don't want the trolls to show. The focus is on her not knowing if she has succeeded of not. Notice the separation of the top half and bottom half of the page. This coincides nicely with the break in this scene's action.

Mirata turns to find the trolls regenerating once again, only now they are much smaller.

This is a reverse angle with a down shot, which reveals the new threat. This is a surprise element in the story, so I feel it deserves the importance of a big panel. Notice the direction of Mirata's figure in these last two panels. I want the reader to feel that she's turned around, so the direction of the view isn't changed.

FINISHED ART AFTER FINISHED PENCILS AND INKING

Another factor in panel composition is balloon placement. It's like a puzzle that you have to solve for each panel, and sometimes it takes a bit of shuffling. You start with what the script calls for and your shot choice. Then, while creating your composition, you figure out where the word balloons can go so they work with everything else. When you find a place for them, make sure it's a space free of any important art. You also need to place the characters in relation to their balloons. Balloon pointers can't cross, so notice the order in which the characters talk. Like panels, balloons read from left to right and top to bottom. Here are some examples to give you an idea of your options for placement. Don't worry, it's the editors job to do the actual balloon layouts for the letterer.

This first panel shows a simple dialogue exchange. The primary location for balloons is a the tip of the pane. The second panel shows how a character can have a second word balloon. The last panel shows how it is possible to have a person on the right side talk first.

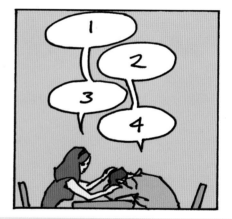

The first two panels show options for either person speaking first. The last panel shows one solution for a back and forth dialogue.

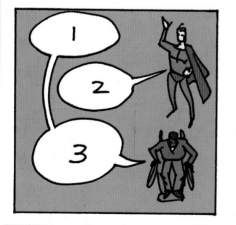
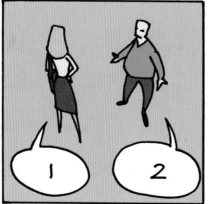
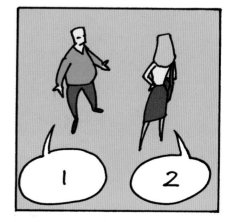

This first panel shows another option for a character having a second balloon. The other two panels show how sometimes you need to change your view in order to accommodate the order of dialogue. Unless you make room at the top of the panel, whoever talks first needs to be on the left.

Covers are a very challenging part of comics. Your drawing skills, no matter how advanced, are not going to be enough. Covers require good use of design and composition for them to work. Another important factor is the idea or concept for the cover image. Usually it's the editor or cover editor that supplies the idea, but I always throw in alternate ideas if I feel good about one.

Most cover ideas relate to a specific event from the story, like a cliffhanger. A cliffhanger is a point in the story where you're not sure if the main character is going to win or lose. Another angle is to show an exaggerated and misleading aspect of the story like the hero dying or marrying an arch villain. Whatever the idea, the main goal is to pique the viewer's curiosity or interest so they'll want to buy the book.

1 Thumbnail Sketches

The first thing I do are small thumbnail sketches where I come up with as many different ideas as I can. For this cover, I wanted an image that introduced some of the characters and presented the flavor of the book. For a couple of the sketches, I tried highlighting the character, as you can see on the left side. I felt they worked OK but I really wanted to show more of my characters. The sketch on the bottom right was an attempt to express something personal about the characters. In it we see them reacting to a danger they all face, crashing their car. For the last sketch (upper right) I picked up ideas from compositions I saw on some anime movie posters. A lot of them use a montage of images to represent their film. I chose to develop this sketch further because I felt it met my idea best.

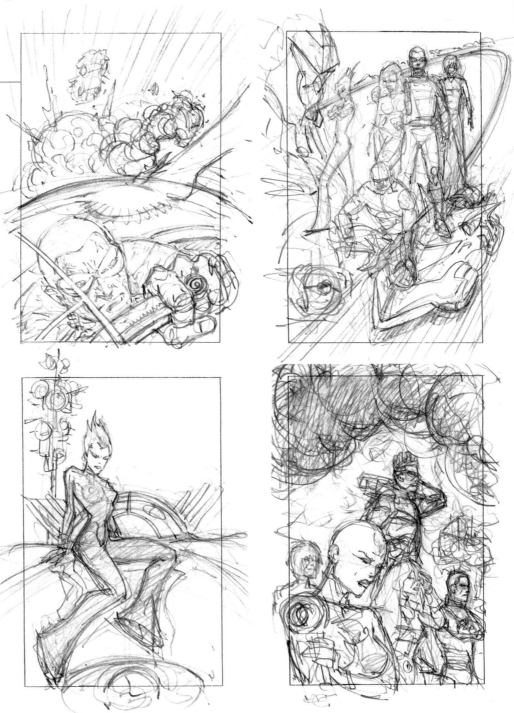

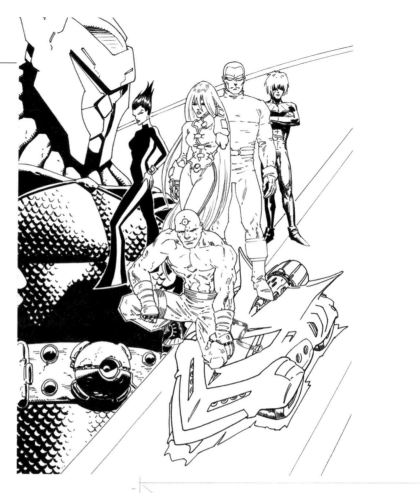

2 Tighten Layout

Now that I have the idea for my image, I can concentrate on its composition. I begin by redrawing the image on 8 ½" × 11" (22cm × 28cm) paper. At this stage you want to be working the same scale as a printed cover. As I redraw it, I tweak the composition, add things and move stuff around. I tightened this one up quite a bit with markers. You can also do it just in pencil. Next, take your image and make an enlargement on the copier, about 145 percent. Sometimes I decide to change the size of elements on the cover, so I'll make smaller and larger copies according to what size I want. For instance, one character might need to be bigger. So, you'll need a larger copy for them. Remember to leave room for the title and any type or logos on the cover.

3 Make Further Revisions With Blue Lines

Put your enlargement, on the lightbox. Tape the bristol board onto the enlargement and use a non-photo blue pencil to transfer the image. I use the blue pencil at this stage because after this you'll be drawing with a graphite pencil. The blue works to show your image but won't interfere with the penciling stage. Notice that I'm not just copying the drawing over. I'm also making changes and adding detail. If I want something bigger or smaller, I use the other enlargements that I made.

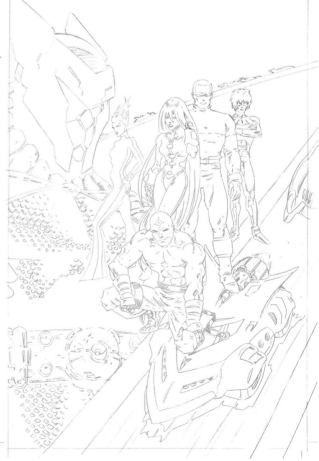

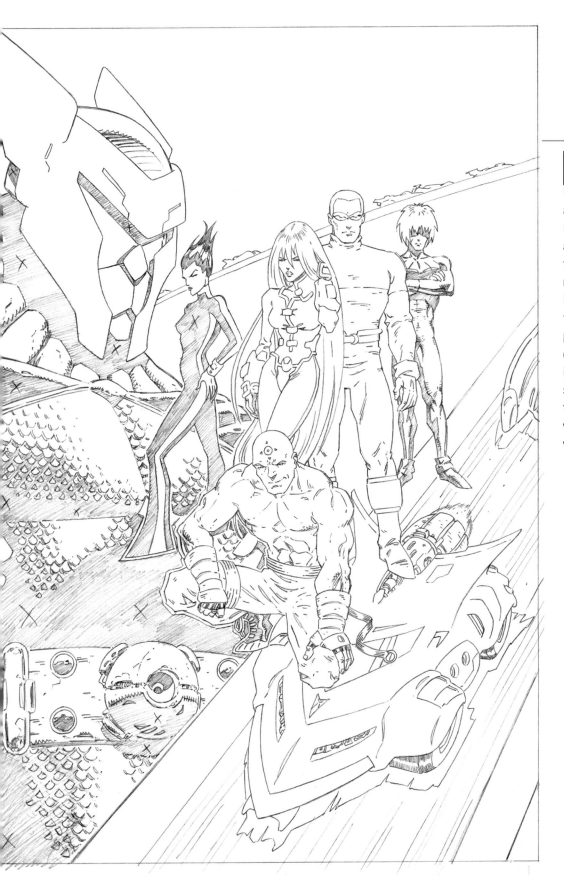

4 Finished Pencils

After finishing the bluelines, I move onto the drawing board and begin the penciling stage. I've got the idea, composition and design. Now it's important to concentrate on inking techniques and details. The "X's" are indicators for the inker to make these areas solid black. Finished pencils are supposed to be exactly like the inked lines, only in pencil. I'm the inker for this, so I'm not putting in every variation of line thickness, but if it were for someone else to ink, you definitely need to.

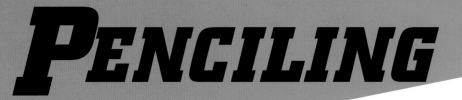

PENCILING

Now that you have all the basics, let's get down to penciling some pages. I'll be taking you step-by-step through my process for constructing a comic page. One thing I want you to notice is that each step deals with separate elements. That way you can focus on individual aspects, such as storytelling or composition, and not be overwhelmed by completing the whole process at once. Having an organized approach like this will help you to consistently produce good work.

Follow the instructions on these pages to create exciting and dynamic comic pages.

1 Read the Script

The script provides you with some basic information for each panel, like who the characters are, what setting they are in, and what is happening. This is referred to as the art direction. It's located after every panel number in the script.

Start off by reading the entire script and make notes for any reference you'll need to find, like a photo of the Empire State Building or a harrier plane. If you're working for an editor, they will supply some reference like characters you don't know or some new design in the Batcave.

2 Design the Characters and Setting

If there are any special characters, settings or other elements that need to be designed, create them now. You'll want to have those things resolved before you start your layouts; plus some may need editorial approval, like for new characters or important locations. Don't go crazy with too much designing though; alleys, hotel rooms or generic things can be dealt with later.

3 Study Your Scene

Now that you've read the script, have a sense of the story's pacing and have designed your major characters and settings, you can concentrate closely on the

Script vs. Plot

With a script you get art direction, the number of panels and all the dialogue. Not so with a plot. The writer provides story information and some dialogue with the plot, but it is up to the penciler to pace out the action. It's more work but gives the penciler more control over the storytelling and visuals.

SCRIPT

Gear Station

PANEL 1 A troll-like warrior confronts Mirata.
Troll: TULGA STANDS READY, GIRLIE! AS HE HAS FOR 500 YEARS!

PANEL 2 They prepare to duel.
Troll: UNBEATABLE, TULGA IS!
Mirata: "SPEAK RIGHT, TULGA CAN'T." ARE WE GOING TO FIGHT OR ARE YOU GOING TO TALK ME TO DEATH?

PANEL 3 The two warriors clash.
Troll: HA! TULGA KEEP GIRLIE'S HEAD AS TROPHY!

PANEL 4 Mirata strikes the troll.
Mirata: "GIRLIE" THIS!

PANEL 5 Mirata flips over the dazed troll.

PANEL 6 Mirata strikes again.
Troll: GYARGH!

TROLL WARRIOR

individual scenes. Read your first scene carefully and keep in mind the following:

- What is the purpose of this scene?

- Does the writer call for any specific shots, such as an establishing shot, close-up or inset panel?

- Locate the climactic point or points of the scene.

- Is there a block of dialogue panels without much action? If it's dull, it will be up to you to make it interesting.

- Are there any actions requiring a sequence of panels?

- Who is talking and in what order?

4 Sketch a Thumbnail

It may help you to sketch a small thumbnail of your panel layout. Keep in mind the following:

- Which shots are going to need large panels?

- Do your panels read correctly and without confusion? (Remember, panels read left to right and top to bottom.)

5 Start the Layout

On 8½" × 11" (22cm × 28cm) paper (use the layout template instructions on page 124, for art dimensions), loosely put down your panel layout. You will be drawing the exact size as the printed comic.

Focal Point

Give each page a focal point that stands out and entertains the reader. It could be many different things, and you should vary it from page to page to add interest to your work. Here are a few examples to give you ideas:

- A dynamic shot of a character
- A climactic point of the page
- A panel with a special composition
- A beautiful female character
- An intricate establishing shot
- A shot with great design elements

On this page, panel 3 is the focal point.

THUMBNAIL SKETCH OF PANEL LAYOUT

Try different configurations until you're sure it meets the needs of your scene. Be creative with your layout design. Take a look at other artists' work and study the various ways they construct their pages. At this stage, you should be thinking of storytelling, pacing, shot types and panel design. At this point, make a simple outline to help keep things straight:

Panel 1: Intro. troll
Panel 2: Both (both characters in shot)
Panel 3: Clash
Panel 4: Mirata hits troll
Panel 5: Mirata flips over troll
Panel 6: Mirata kicks troll

LAYOUT SKETCH

At this stage, concentrate on the gesture of figures, composition, cropping, structure and balloon placement. Reference material can be used at this point but don't get detailed. The impression of something is more important here.

There are many advantages to working in true scale at this stage. If you just drew on the large board size, when it's reduced for printing your drawing would become too tiny. Another advantage is greater control over proportions. If you draw the same thing twice, one large and one small, you'll find the smaller scale drawing is much easier to control.

It is important in these early stages to incorporate the dialogue and captions with the artwork. It's sort of a puzzle that you have to solve, and often their place-ment influences your choice of shot. You'll also need to leave sufficient room for dialogue. Factor in your character's placement in relation to who talks first or last. You don't want to create conflicts when the dialogue is added.

Stay loose at this stage. Your drawing should be gestural, not detailed. Take advantage of that energy and any happy accidents that occur. This is also when you will add the structural drawing, such as anatomy, perspective and construct-ing with shapes.

6 Revise Your Layout

Now you're ready to enlarge your layout and go to the lightbox. This stage, how-ever, is not about copying the last step. You are refining your image, adding detail and resolving any problem areas. Use rulers and circle templates to perfect your shapes, angles and proportions. Using a copier, enlarge your layout 150 percent onto 11" × 17" (28cm × 43cm) paper. You can also tweak your layout by en-larging some parts more than others.

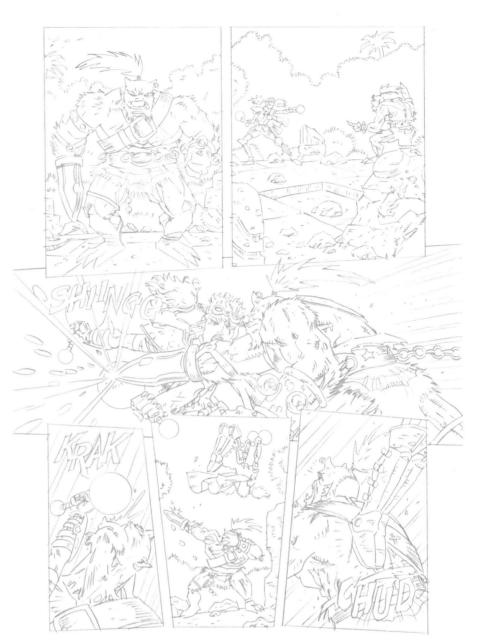

BLUELINE

Here you're focusing on refining and correcting your images. Also use any templates or rulers. Reference material is used most at his point. Now is the time to be more accurate and detailed.

11" × 17"
(28cm × 43cm)
Board

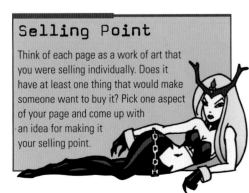

Selling Point

Think of each page as a work of art that you were selling individually. Does it have at least one thing that would make someone want to buy it? Pick one aspect of your page and come up with an idea for making it your selling point.

Using your non-photo blue pencil, begin the process of transferring your layout to the finish board (use the art board template on page 125).

7 Finished Pencils

Now you're ready for the drawing board and the penciling stage. In a way, this step is really about inking, only we'll be inking with graphite. For comics companies, finished pencil drawings should look identical to the final inked work. Indicate solid blacks by marking an "X" over the shaded area. Now you can do all the detailed drawing you like. Go crazy!

FINISHED PENCILS

This is the final stage. Concentrate on creating clean finish lines that mimic inking techniques. Pay attention to achieving various textures in your art.

11" × 17" (28cm × 43cm)
Board

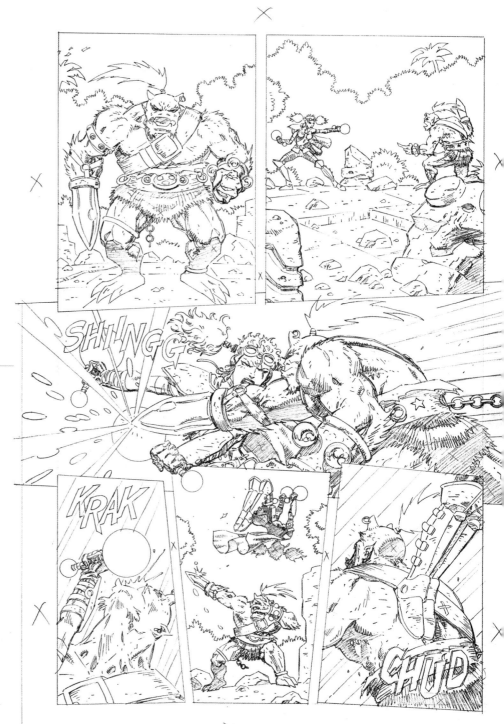

Avoid Smudges

Fold a piece of 8 ½" × 11" (22cm × 28cm) paper in half and use it to keep your hand from smudging the drawing as you work.

INKED AND COLORED

Here's the final product except for word balloons. One unconventional thing about this page is that I used wash tones in the inking stage. You will learn about inking in chapter 4.

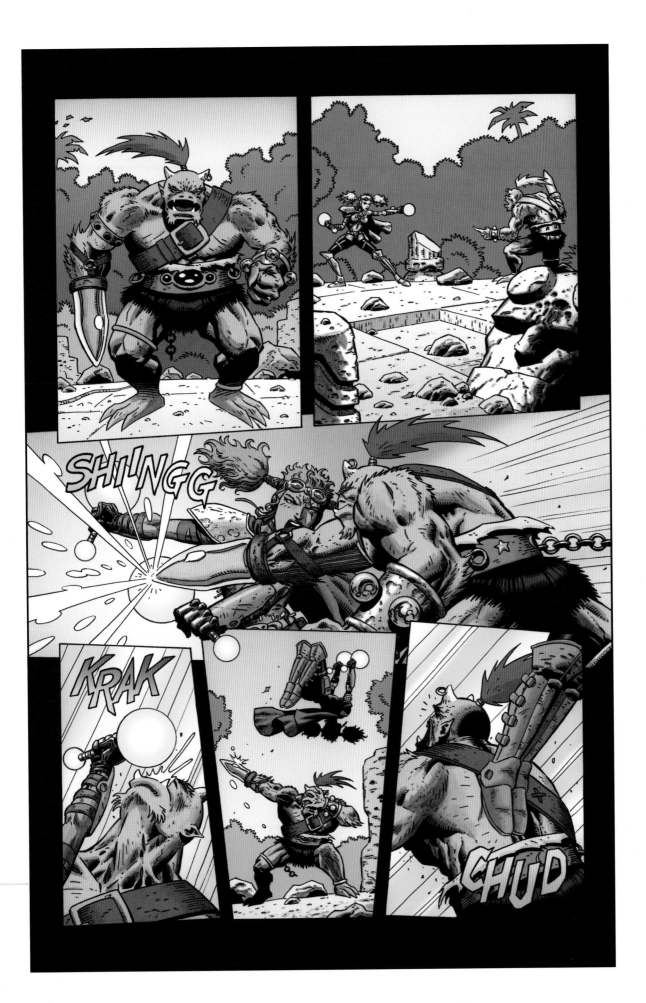

Here is another example of how to build a comics page. This example uses overlapping panels to create a unified look.

To build on the basics that you learned in the first demonstration in this chapter, remember to follow these steps in the process of creating your page.

- Thumbnail: storytelling, shot angles, panel layout

- Layout: gesture drawing, composition, creativity, structure

- Lightbox: refining, correcting, rendering

- Penciling: finish line, inking techniques, textures

Layout

Here's how I came up with my storytelling and layout.

Panel 1

I wanted a dynamic shot that would create the impression that Stealth is going mach speed in his spy plane. To convey how fast he's moving, I used a combination of extreme foreshortening (his right arm) and a strong feeling of perspective. To push the feeling of speed and per-spective, I designed the cockpit with a lot of long, horizontal shapes. The panel also bleeds off the page because I didn't want panel borders to stop the eye.

Panels 2 and 3

Looking at the rest of the story for the page, I combined the dialogue so it all reads as one panel, only with different views so the dialogue balloons would run down the center border. The balloon pointers would then go to the left or right depending on who's talking. I used a down shot for panel two of the command center because it gave the best view of the Cybernetic Man and the equipment. It also contrasts well with the angle in the first panel. I like that the view surrounds this robot character with technology, reinforcing that he is mechanical, not human. Coming up with symbolism like this helps when you are trying to develop ideas for your images.

The overlapping panels bring across the idea that they're all in close communication. The girls, Gadget and Tarot, are in video frames to indicate that they're inside the falling containers. Consider these last three views as one panel.

SCRIPT

Spooks

PANEL 1 Night; Stealth is in the cockpit of his hi-tech plane.
Stealth: THE PACKAGE HAS BEEN DELIVERED.

PANEL 2 The Cybernetic Man is alone in a small command center. He has cables and wires connected to his back. He's pressing a switch on a communications console.
Cybernetic Man: COMMAND TO TAROT, COME IN.
Tarot (radio balloon): I'M READING YOU.
Cybernetic Man: YOU HAVE A GREEN LIGHT. I REPEAT, A GREEN LIGHT.
Tarot (radio balloon): RODGER THAT, TAROT OUT.

PANEL 3 Tarot and Gadget, dropping out of the night sky, each in some sort of high-altitude containers.
Tarot (radio balloon): GADGET, GIRL IT'S TIME TO GET YOUR FREAK ON!
Gadget (radio balloon): 'BOUT TIME, I FEEL LIKE A SARDINE IN THIS THING.

THUMBNAIL SKETCH OF PANEL LAYOUT

For this layout, I wound up with both the first and second panels as special panels. The first because it's a cool view of Stealth in his plane. The second is special because it's the only panel I'll have with this character for the whole story. This scene is about their radio communications. That made me think about overlapping the panels to reflect the connected quality of their conversation.

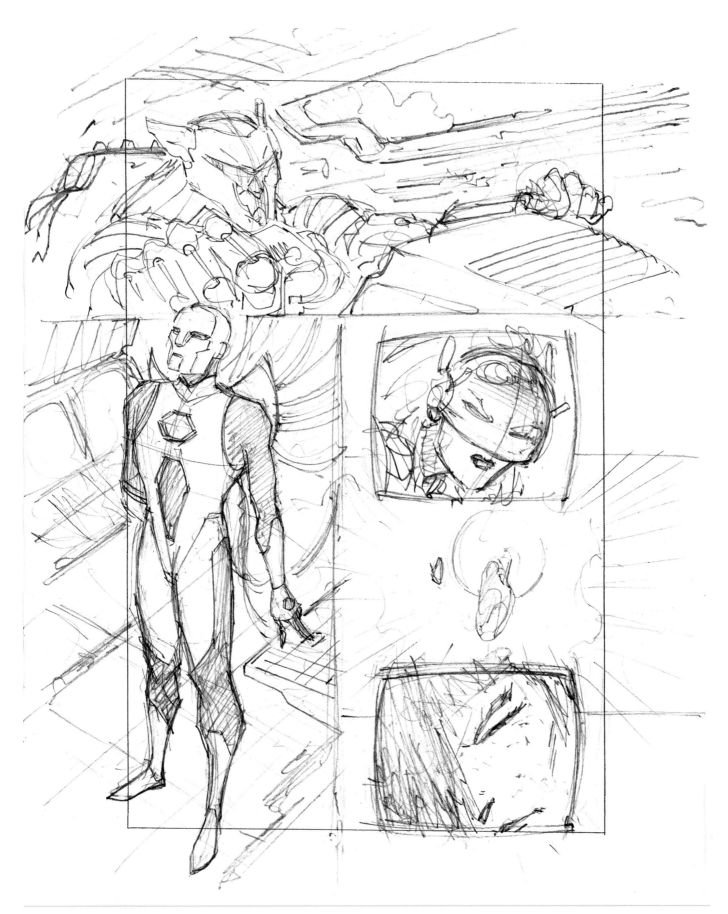

ROUGH SKETCH OF LAYOUT

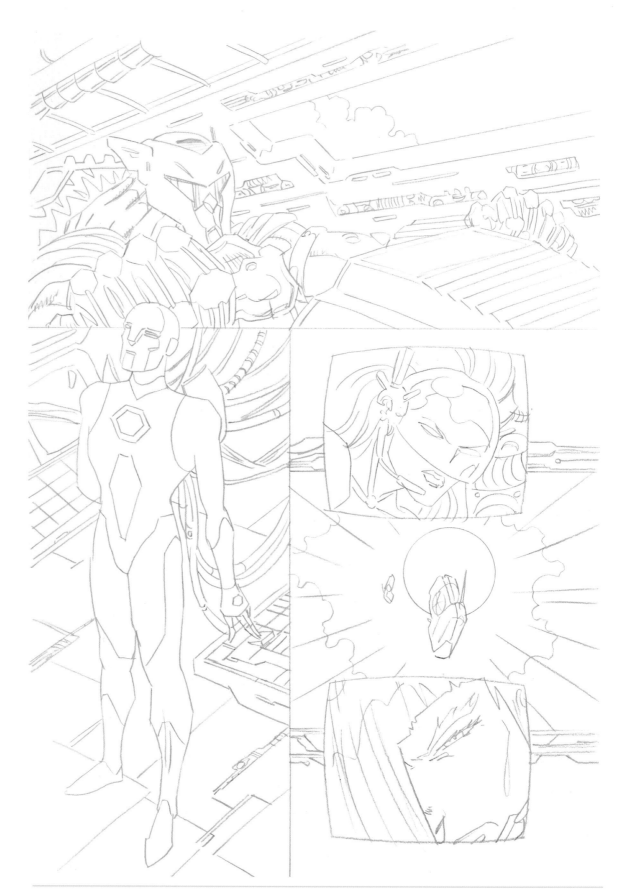

BLUELINE

Now the art is enlarged 150 percent and you've drawn it on the lightbox. This is where you can concentrate on details and cleaning up your rough pencil sketch. Notice that I added circuitry to the last border as a design element. It adds an interesting visual and ties in with them being linked by technology.

11" × 17"
(28cm × 43cm)
Board

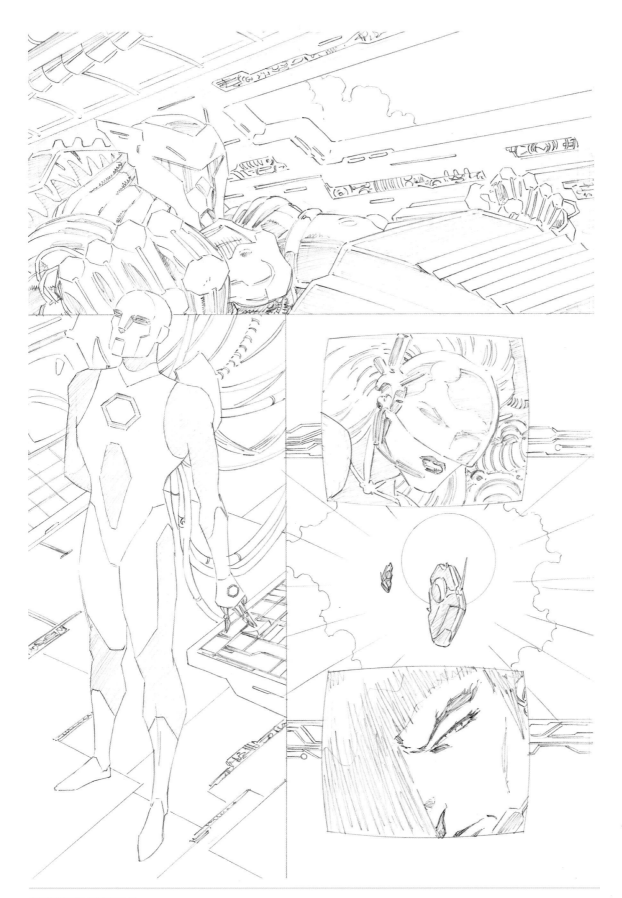

FINISHED PENCILS
11" × 17" (28cm × 43cm)
Board

This is an action scene so there's a couple of things you need to consider. One is choreography. Even though you're drawing still images, you need to envision the movements in between so, you don't get contradictions. If someone strikes with their right hand they usually strike next with their left. Believe it or not, it's also very easy to get confused and put somone's weapon in the wrong hand. Another factor is how you pace it; you want the fight sequence to have character. Think about how it builds in action, where it climaxes and which parts need the emphasis of big panels.

Layout

Here's how I came up with my story-telling and layout.

Panel 1: The preceding page was a splash page, an image of Adara (see page 10), so now I pull back to a medium shot to establish both characters in relation to each other. I keep the view at eye level because it's the beginning of their fight—the calm before the storm.

Panel 2: There's sudden action so I change my view drastically. The slightly elevated view helps create a sense of movement and conflict.

Panel 3: It's an action scene so I make another big change in shot angle. Using the up shot as well as pulling in closer, adds to the surprise of this sword thrust.

Panel 4: For this panel I superimposed the Queen, rather than have her in the distance. It's important to see her expression. Superimposing works to show her as well as the characters fighting. I like the tension it creates too; the Queen's cold emotional detachment right next to the heated life-or-death battle. The view of the Queen is slightly upward to present a more regal impression.

SCRIPT

Amazons

PANEL 1 The two Amazon gladiators face off against one another with swords; bodies litter the arena. Herta has a shield with a knife attached to it.
Adara: YOU MADE THE CHOICE TO BE HERE, HERTA. I WON'T HOLD BACK FOR YOU!

PANEL 2 Adara attacks but Herta blocks the sword with her shield.

PANEL 3 Adara is shocked by Herta's sword thrust, which nearly takes her head off.
Herta: GOOD....

PANEL 4 The Amazon Queen views the combat with cool indifference as Herta wounds Adara.
Herta: ...NEITHER WILL I!
Adara: AARGH!

Sound Effects

Putting in sound effects is up to you. It's actually the letterers job, but I enjoy making them part of my composition. Sometimes it's fun to incorporate them directly into an image.

THUMBNAIL SKETCH OF PANEL LAYOUT

The first panel here needs to establish the fighters and their setting. Think of it like a newspaper headline. It's prominent and sets up the story. Then panels two and three follow with actions based on that panel; there's less information so they get smaller panels. For panel four, there's a surprise action, so I make that the special panel. I decide to superimpose the queen in panel four, so I can show her and the fighters well enough. To help separate her a little from the rest of the panels, I put a blank space before panel four.

ROUGH SKETCH OF LAYOUT

BLUELINE

Here again the layout is enlarged 150 percent. The bristol board is then taped onto the copy. Using non-photo blue pencil, the image is redrawn, making improvements to the rendering. At this stage, take advantage of any happy accidents you see. Within the many lines of your layout, you might see something good that you didn't intentionally draw.

11" × 17"
(28cm × 43cm)
Board

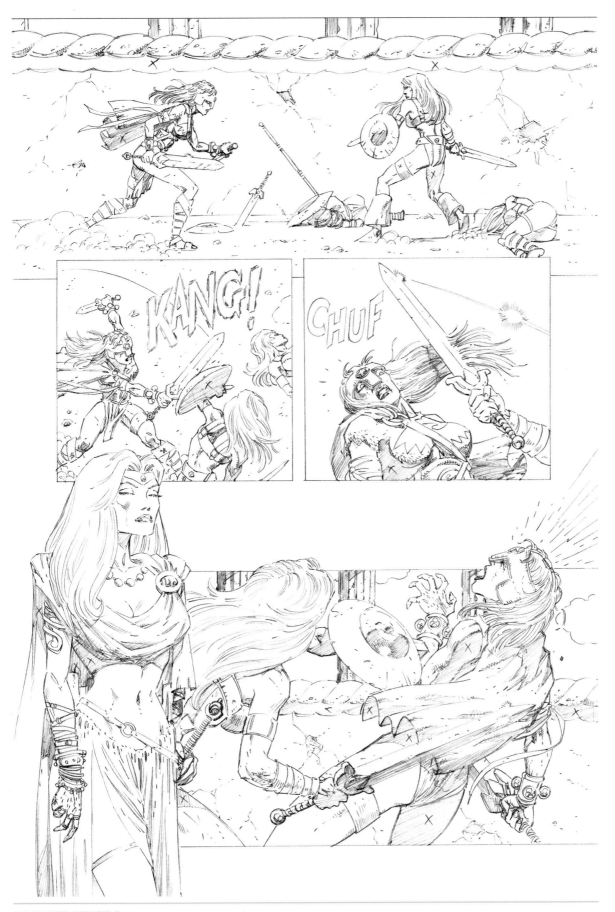

FINISHED PENCILS
11" × 17" (28cm × 43cm)
Board

Here's a scripted page for you to practice doing a layout. Use the layout template instructions on page 124, so that your drawing is on the same scale as a printed book. My solution for this layout appears on page 102. If you can, try doing yours without looking at it. For the character Zeva use the female hero design on page 44.

One thing that might help you is that the preceding page for this script is a splash page. It's an up shot showing her jumping toward us off a small hovercraft vehicle.

SCRIPT

Amazons

PANEL 1 Night. A city on an alien world. Zeva leaps to the roof of a hi-tech building. A locked access is visible on the roof. She activates an energy field that surrounds her like a big bubble.
Zeva: ACTIVATE DAMPENING FIELD...NOW!
Computer (radio caption): DAMPENING FIELD ACTIVATED. TEN SECONDS TO SHUT DOWN...9...8...7...

PANEL 2 She's disabled the lock with her sword and is opening the access door. The energy bubble is disappearing.
Computer (radio caption): ...3...2...1. DAMPENING FIELD OFF LINE.
SFX: ZZZAT!

PANEL 3 Moving along the ceiling structures, Zeva spies a security guard on his rounds.
Guard: SECTION SEVEN'S A CLEAN SWEEP. HEY, POP MY GRUB IN THE HEATER, WILL YA. I'M STARVIN'.

PANEL 4 She's dealt with the guard and is already using her sword to break the lock for a large security door.
Guard's communicator (radio balloon): RODGER THAT. ONE ICE BLOCK, ON INCINERATE.
Computer (radio caption): ...TURN FIVE DEGREES TO THE RIGHT...LOCK DISABLED.

PANEL 5 Inside is a lab full of large hi-tech containers (big enough for a person). Zeva strides confidently toward a small console sticking up out of the floor.
Computer (radio caption): INSERT ACCESS CARD AND KEY IN SEQUENCE 983264.

PANEL 6 Inset panel. A close-up as she's inserting a special keycard into a slot on the console.
SFX: CHAK!

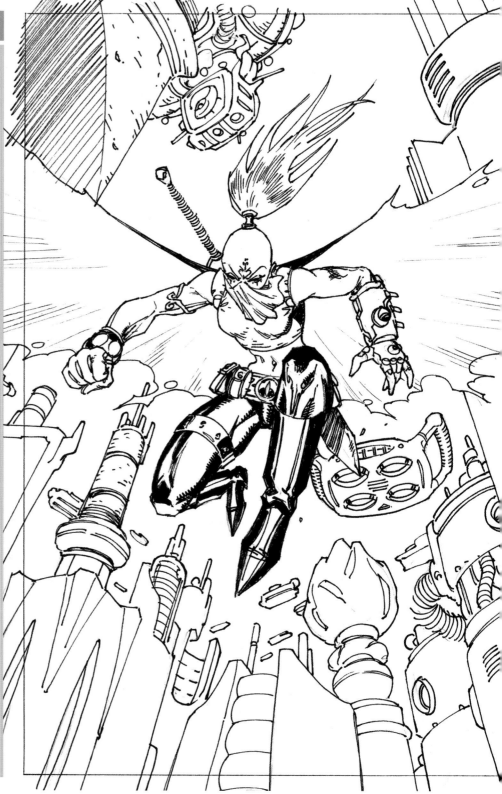

ractice your penciling with these two sketches. You will follow the process of making enlargements, resolving design issues with your bluelines and revising your bluelines into the finished pencil drawings. The story involves a spy making a high-altitude parachute jump.

1 Enlargements

Make enlargements of each of these images onto 11" × 17" (28cm × 43cm)

paper. The outside rule needs to be 9" × 14" (23cm × 36cm).

2 Create Bluelines

On the lightbox, transfer the drawings onto comic boards using a non-photo blue pencil. Remember that this step is not just copying; you are resolving the image. That means adding details and changing the sketchy lines into single, clear lines. At this stage you're also making corrections. For example, on the

first page, use a circle template for the moon and the character's helmet.

3 Finish Penciling

With your completed blueline, go to the drawing board and complete your finished pencils. Concentrate on creating inking qualities in your drawing.

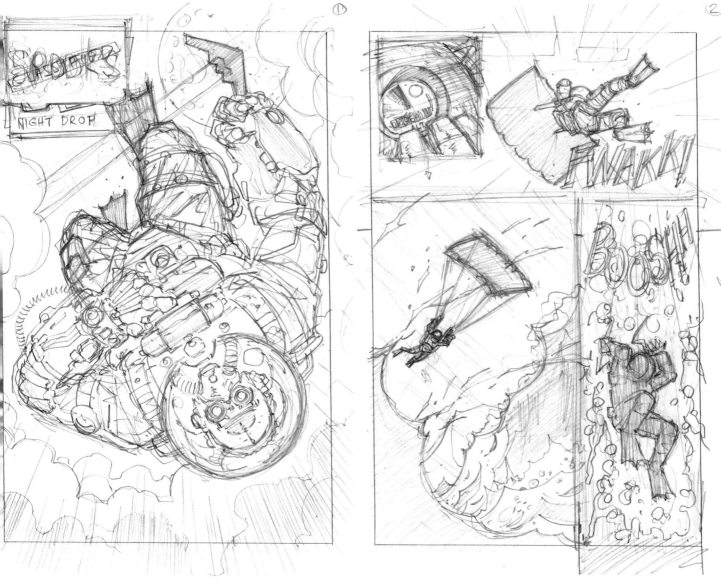

Here, remember to make decisions about adding black areas to your composition. The black areas I decided on are marked with an "X."

For the costume design, make sure you're thinking about your shapes having a three dimensional quality.

Here's my solution for the layout exercise from page 100. This is also a good opportunity to show you a method for tightening your layouts.

Panel 1: The down shot allows me to establish the character in relation to the roof. I also want to make it obvious that she's heading for the locked door. I didn't feel the need to focus on her too much because the preceding splash page did that. The bleed off the top creates a stronger vertical, that helps give the feeling of her dropping down. It also works as a visual cue for her entering the scene.

Panel 2: I did a reverse angle, from the last shot, so you can see clearly that she's broken through the door. I also didn't want to have an entire page without at least one shot of her facing toward the reader.

Panel 3: The panel jumps into a reverse angle again, giving you a good view from her perspective. Always keep in mind ways that you can let the reader experience what the character is doing.

Panel 4: There's not much need to focus on how she subdued the guard so I use a low angle shot that shows him unconscious and her working on another door. I also made this panel a different shape and separated it from the top three because there is that little jump in the story of what she did to the guard.

Panel 5: I pull back for a long shot and make it a bigger panel because a surprise element is being revealed. I bleed off all around to make it seem bigger and uncontained. I also overlapped the previous panel to create a nice layering effect for the page design.

Panel 6: For the inset panel I chose an extreme close-up because it's more suited for this small piece of story information. I gave it a wide border to separate it from panel five.

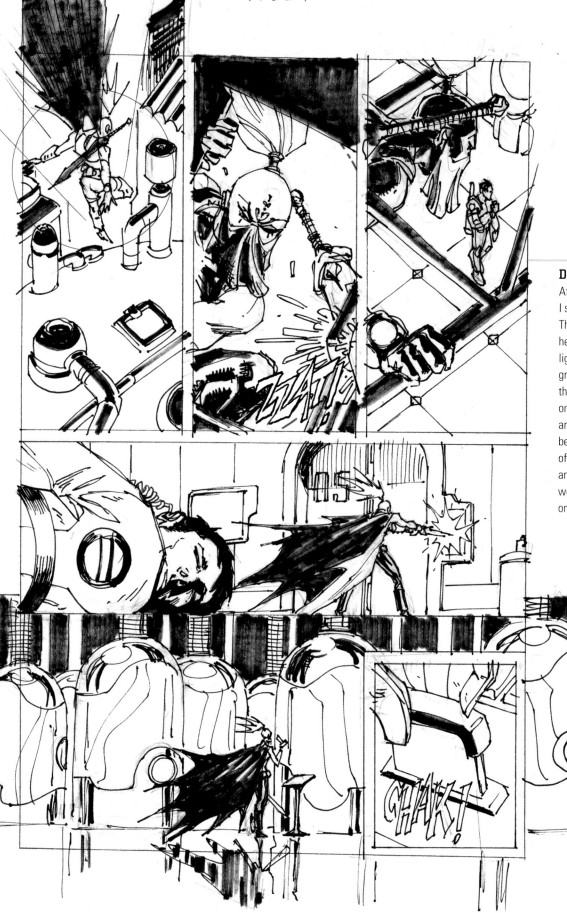

DEFINE YOUR LAYOUT

After I sketch my layout with pencil, I sometimes go over it with markers. This further defines the image and helps when you redraw it using the lightbox. This marker stage is also great for deciding where to place the blacks. Use a thicker marker or one with a chisel tip. The larger tips are great because they force you to be looser with your rendering. A lot of happy accidents occur doing this, and you really notice them as you're working from your enlarged layout on the lightbox.

A splash page is a little like a cover and a little like a big panel. Its purpose is to be something dynamic, surprising or impressive, sort of a cymbal crash. It's not always the first page—sometimes it can be a double page spread—but it's usually placed in the first few pages of a comic book.

This is a splash page I did for my book, *Redblade*. I wanted a dynamic shot of this character, Tull, in a grouchy mood. My first idea was to draw an intense close-up and then reveal him having captured the heroes on the next page. Instead, I opted for putting all that story information on the splash and showing where he is and who he's talking to on the next page. If you were working from a script, however, all this would be included in the writer's art direction.

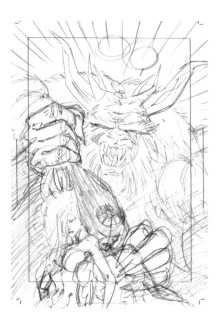

LAYOUT SKETCH

LAYOUT SKETCH

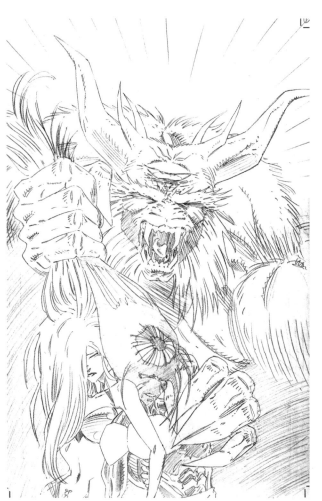

FINISHED PENCILS
11" × 17" (28cm × 43cm)
Board

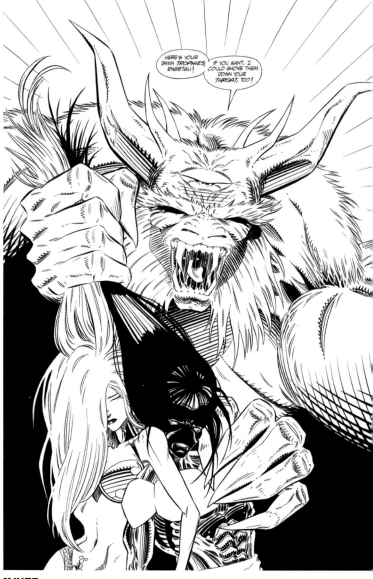

INKED

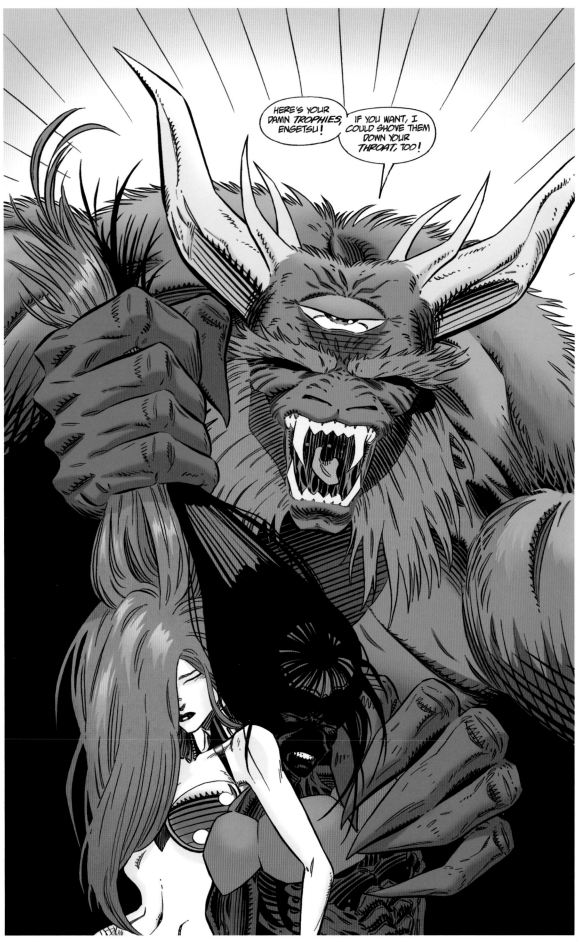

FINAL COLORED PIECE

INKING

Inking developed in comics because lines needed to be dark enough for print-
ing purposes. Now, new printing technology allows for more options, but ink-
ing bold lines is the standard for comic art. The basic inking tools are brushes
and pens. I recommend that pencilers learn inking too, because finished pen-
cils need to show inking techniques. Another reason is that at some point,
you'll probably need to ink some of your own work.

The two main purposes for inking with brushes are to create thick lines and fill in black areas. The brushes used for inking are sable brushes. Look for the Windsor & Newton Series 7 or Raphael Kolinsky sable brushes. I recommend using nos. 1 and 2 rounds. Some artists use a no. 3 round brush too.

Line weight is a big part of brushwork. It is used to change thickness in a line to create depth in your image. The general rule is that thick lines come forward and thin lines recede. To vary the line weight, press the brush down slightly as you make your stroke. This puts the thicker part of the bush in contact with the paper, creating a thicker line. If you then pull back up slightly you can create a thin line.

Loading Your Brush

When you dip your brush into the ink, don't submerge the whole bristle. This action will eventually cause the hairs to flare, and shorten the life of your brush. You only need to dip it in the ink about half way. You also need to do what's called pointing the brush. I recommend using a cup so you can be precise with getting ink. Just drag the brush up the inside of your ink cup until it's a nice, smooth pointed shape.

Brush Care

At the end of the day, always clean your brushes with soap and water. Be gentle with the bristles—you don't want to ruin the shape of the brush. Replace brushes when the bristles get too spread out.

LONG STROKES

Brushes are great for making long, graceful lines. Hold your brush at about a 45-degree angle in the same direction as the line you are inking. When you make a long stroke, move your whole arm. The side of your hand can touch the paper to give you control, but make sure you're pivoting from your shoulder. If you use a pen, it will deposit a large bead of ink on your paper, and that takes a long time to dry. As for brush size, a no. 2 can make a thicker line than a no. 1 They both make similar lines depending on how you point the brush.

SHORT STROKES

For shorter lines, rest your elbow on the drawing board and move your arm from that point. Making thin or thick lines is just a matter of varying pressure.

CRESCENTS

Make a "J" shape with your brush. To create crescent shapes, start and stop the stroke with the point of your brush. For the mid-stroke, don't turn the brush; just press down slightly. The whole stroke is a dipping movement. It's good for creating scales or armor with little metal plates. A no. 2 works better for this because it's thicker.

Pens, or what some people call quill points, are used for linework. There are many types of pen points to choose from. You'll have to try quite a few types to find what you like best. To start, look for three different points: one flexible, one stiff and one that's a little of each. There are two sizes to choose from: one is a half-round shape that fits in a large pen holder, and one has a round shape that fits in a small pen holder. A good point to start with is the Hunt 102 Crowquill. This is widely used by inkers. If you find one that you really like, buy a bunch of them because sometimes they get discontinued.

Use the flexible pen point to make lines that vary in thickness. This is good for lines on the figure because you want to vary the line weight, but you need more control than what the brush offers.

Use a stiff pen point to make a line with uniform thickness: a dead line. Use this on backgrounds. You want those lines to recede, and that's what you get with a thin dead line.

When dipping the pen into the ink, try not to load the point too much. Don't cover the hole in the pen point. I use a small cup with a big enough opening so I can see exactly how much ink I'm getting. If it does load up too much, just touch it to the lip of the cup and bleed off the excess. In general you must pull the pen across the paper; if you push it forward, the tip will catch on the paper and splatter ink.

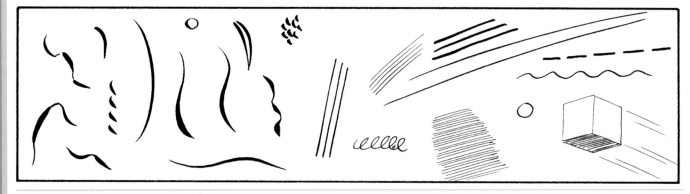

PRACTICE LINE VARIATIONS

Using a medium flexible point enables you to get good variation in line weight, but you can also get a dead line by using even pressure. Try creating a variety of your own lines. These were all make with a medium flexible point.

Usually, an image is inked using a combination of brush and pen. To give you a feeling for the differences between them, here are two examples of the same image, one is inked with a brush and the other is inked with a pen. Let's examine the qualities that each one has.

BRUSH

Notice the loose, expressive nature that you get with the brush. The looseness makes a more realistic-looking image. I noticed when filling in the cape that the brushstrokes created a feeling of fabric, so I left it. That's a nice, happy accident that often occurs when using a brush. As things emerge, you take advantage of them. As you can see, laying down thick lines or putting in line weight is more conducive to the brush. I also used a couple of texture techniques for the sky: dry brush and toothbrush spatter.

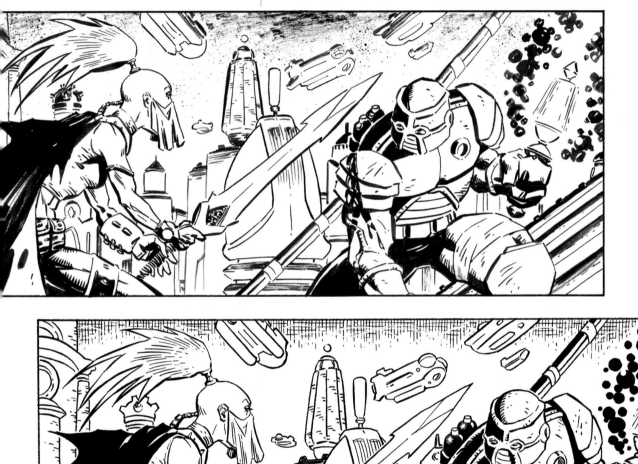

PEN

The pen makes a sharper, more focused image. On the down side, that crispness of line diminishes the depth. Unlike the brush, there's more of a similarity between the lines in the foreground and the lines in the background. Pens, rather than brushes, give you the most control in rendering an image. I only used a brush to fill in the blacks for this piece.

These are basically designs or patterns that create shading effects. It's very important for pencilers to know these so they can use them in their finished pencils. Learn these techniques, but also think of them as designs that you can change and make your own.

FEATHERING

This is a technique for creating a mid-tone shading effect. A brush or pen can be used for feathering. One form is a series of parallel lines that are thin at one end and thick at the other. The thick end meets up with a solid black, creating a gradation effect.

FEATHERING ON FORMS

The direction of the parallel lines has to do with how the object is tipped in space. Feathered lines should follow the form of the object. The images on the right show how you can create variations on basic feathering.

FEATHERING WITH A PEN

One way you can feather with a pen is to make a series of waves up against a line or black shape. As you can see, there are many different ways of forming these.

Feathering Technique

1. Start by drawing a thick stroke from the crest of the "wave" to the bottom.
2. Lightly go to the next crest.
3. Repeat the thick stroke again.
4. Repeat the first three steps until you have a whole row. With practice, you can create a row of these as easily as writing a word in cursive.
5. As with other feathering, it's used along side a thick line or black area to create a shading effect.

GRADATION

Gradation is a series of parallel lines that range in thickness from thin to thick. As the lines start thick and steadily get thinner and farther apart, the gradation goes from dark to light.

USING GRADATION

Gradation is great for making reflective surfaces. Here it changes a flat circle into a sphere.

Crosshatching

Crosshatching is a series of intersecting lines that form an even pattern or gradated shading. Basically, you put down a set of parallel lines called hatching; over that you put another set of hatching, only at a different angle. The angle can vary, depending on what you like. You can put down as many layers of lines as you like, though typically artists use only two or three layers. There are two basic methods to crosshatch for shading effects. See methods 1 and 2 on this page.

Ink Wash

Ink washes are another way to create shading effects. This technique uses values which are made by diluting ink in water. Having three values work best: a light, medium and dark. Apply them with a brush. They are used most in black and white printing, but they can also be used in color printing. Wash tones are also great because you can use them alone, without black lines, for cool effects. For more on wash tones, see how they were used in the art on page 91.

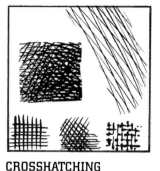

CROSSHATCHING

METHOD 1
Put down layers of staggered hatching to create varied degrees of density.

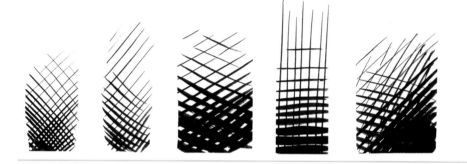

METHOD 2
Put down lines the same as for gradation, only in the pattern of crosshatching.

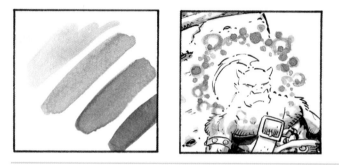

INK WASH
I used the ink wash and a brush to create an energy or magical effect.

CREATE A METALLIC SURFACE
Here's an example of using the second method to create a metallic surface. The crosshatching simulates a reflective surface.

MAKE PATTERNS WITH CROSSHATCHING
Use crosshatching and the point of your brush to put down lines in a less uniform way. Instead of parallel lines, just sweep back and forth at different angles until you get an evenly dense pattern.

COMBINATION
This image contains feathering, gradation and varied line weight. Notice how the gradation creates the illusion of reflected light. In case you're wondering, it's a collar bone and part of a neck.

Learning different textures lets you create the illusion of different surfaces using various line qualities and shapes. Each texture can have different uses. For example, the texture for skin wrinkles can also be used to create cracks in mud.

FAMILIAR TEXTURES

These drawn textures tap into the visual language of comics. We either associate them with specific characters, or they've been used so much that they're a comic standard. When readers see them, it sparks a connection that can bring something special to your image—almost like a cameo appearance of your favorite superhero.

REPTILE SKIN OR ROPE

This could be reptile skin or a coil of rope. Use a brush to make many rows of crescent shapes.

ALIEN SKIN OR OCEAN ICE

This could be the skin of an alien or maybe packed ice on the ocean. You can make this very quickly with a brush.

FIRE

Fire is pretty simple. It's a series of inward-facing arcs with lines that are thick in the middle and thin on the ends. Using a flexible pen point works best.

WRINKLES OR MUD

For wrinkles, use thick and thin lines. Put some white lines in with a correction pen to create more texture. If you get rid of the eye, this could also be a good texture for muddy ground that's dry and cracked.

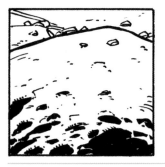

SMOKE

Smoke can be billowy or wispy. Create it using a dead line (a line that doesn't change in thickness). To give wispy smoke some depth, think of it as a ribbon shape.

WOOD GRAIN

Wood can have many different grain patterns, but it's basically parallel lines that are broken in places. The other quality is how weathered you make it look. Here I added some little dashes to create a more indented surface. Add more dashes to make it really gnarly, and long shadows for deep crevices.

ROCKS

Rocks could be a whole genre themselves since there are so many different types. Generally, create them with solid blacks for shadows and thin lines for cracks and small pits.

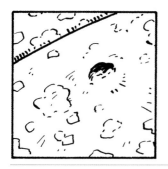

RUST

For rust, use a dead line to make various incomplete blob shapes. Then add dashes and specks to make it look more crusty.

METAL AND CHROME

Create metal or chrome using a varied line weight to simulate the reflections on its surface.

BRICKS

The surface of brick is similar to stone, only it's a geometric form. To add depth, give it a strong shadow and leave out most of the edge that's facing the light source. Remember to add the staggered pattern to the bricks.

SPARKS

Here's an interesting way of making sparks. It's kind of like an exploding flower that has rectangular petals.

FUR

For fur, use a series of short, arcing lines. Use a dead line unless showing it up close; then use a varied line weight.

MARBLE

Make a marble surface by putting down black, angular shapes with a brush. Then use the correction pen to draw the vein-like lines.

DRIPS

Make drips by using broken lines and a reflection line on the bottom of the shape.

REPTILE SCALES OR ALIEN SKIN

Combine techniques to create a new texture. This could be used as reptile scales or alien skin.

MOON SURFACE

Here's how you can use drawn texture to create a really tactile moon surface. Use a correction pen to draw back into the ink to make it look a little more scarred. I also used the correction pen for the stars.

Here are several types of texture made from various tools. These are great to use in your work because they add variety to your inking and interesting effects to your panels. You can create a feeling of speed or motion, make smoke or explosions and many other textures to add excitement and drama to your art.

RAZOR SCRAPING

Using the point of a safety razor, scrape across the ink to create white lines. This is good for showing speed or movement. It does rip up your board quite a bit, so save it for last.

FINGER PRINT

Put down some ink with your brush and use your thumb like a rubber stamp. It's good for bloody finger-prints, patches of blood, clouds of smoke or just a more expressionistic area of black.

DRY BRUSH

Dip your no. 2 or no. 3 round into ink and wipe most of it off with a paper towel. With very little ink on your brush you get a nice, grainy effect. It's good for texture, fog, a midtone shading or something far away and hazy. You can also do this with white ink.

PAPER TOWEL

Dip a paper towel in ink and stamp it around to create a three-dimensional texture.

SPATTER

Dip the front edge of an old toothbrush into ink, then flick it with your thumb to spatter ink onto the board. It can be a little hard to control, so cover the other parts of the page with paper to protect them. It's good for blood spray, fog or just a background effect. It works with white ink, too.

CORRECTION PENS

Use these pens to create white lines or dots. They're good for motion lines, correcting mistakes, stars or drawing details into inked work—like veins or hair.

GREASE PENCIL

It's good for shading tones or adding a grainy texture. It smears, so use it after all erasing is done. (Then again, smearing it with a pencil eraser could create an interesting effect.)

This panel illustrates how to use the brush first and then the pen. This method takes advantage of the looseness and spontaneity that you get with the brush.

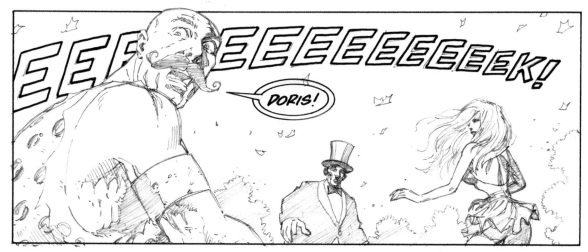

FINISHED PENCIL DRAWING

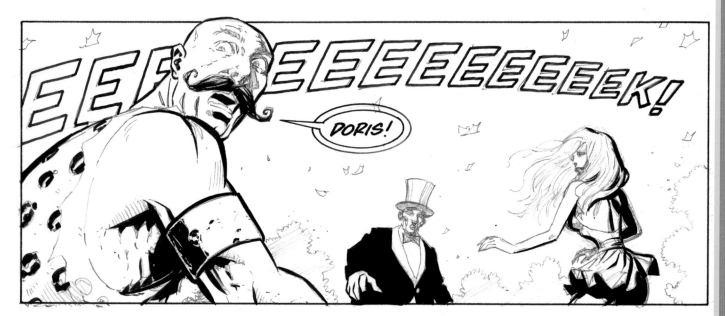

1 Brushwork

Use your no. 2 brush to put in thick lines. Look for these three elements:

Depth: Thick strokes make lines come forward, as you see with the strongman's shoulder and arm band.

Line Weight: Lines of varied thickness follow the form of an object to create a three-dimensional effect. Notice the contour lines on the strongman's face. .

Spotting Blacks: I put some black areas in at this point, but not the ones that require pen work first, like the trees or facial features. Blocking in these dark areas help define the forms, giving them depth and shaping.

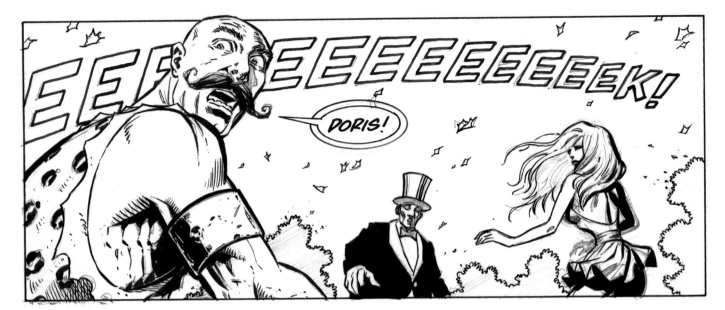

2 Pen Work

Render shapes and apply feathering techniques to the more detailed areas with the pen. Use it for lines that require more accuracy and control for their execution. For the background trees, the pen gives you the leaf-like shape you want. Another reason for outlining a black area is to keep it crisp. Sometimes when you erase your page after inking, some of the brushwork will lighten, especially around the edges. This has to do with: the amount of ink deposited on the paper and the quality of the ink.

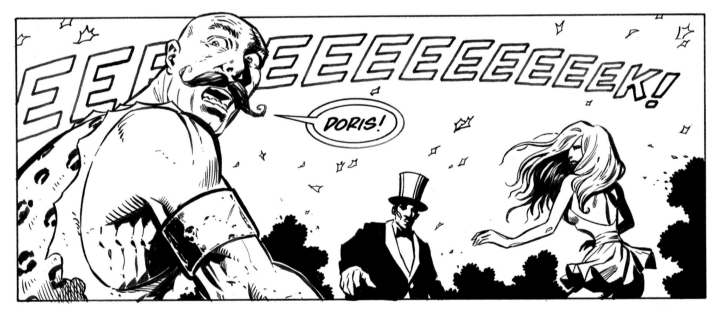

3 More Brushwork

Go back in to fill in black areas with the brush. Look also for any thick lines that need to be added.

Finishing Touches and Clean Up

4 Finish with using a correction pen to add some white lines. Notice the creases on the strongman's forehead, some hair crossing into a black area on the girl and the cuff and buttons on the ringleader. I also used the correction pen to fix the white outline around the strongman's arm and some errant lines outside the panels. When you finish, go over the entire board with your kneaded eraser to get rid of any pencil lines.

This next example demonstrates using the pen first. This method may be a little faster than the last, but only if you restrain yourself from going too far and doing the lines that require a brush. If you use your pen to create really thick lines, you could wind up depositing too much ink on the board and you'll have a long wait for it to dry. You could work on more than one page, so it's not a problem, but don't be in a hurry to mass produce. Concentrate on quality, not quantity.

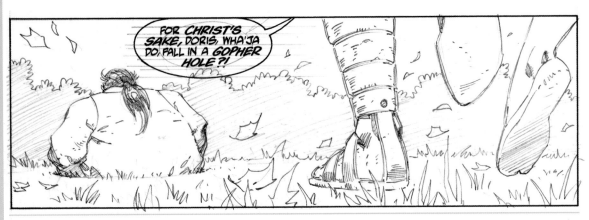

FINISHED PENCILS

1 **Create Depth With Your Pen**
Start by inking as much of the linework as you can with the pen. I recommend a medium flexible point. The basic principal for line weight is: to use thick lines or lines with varying weight in the foreground, because they advance, and use thin, dead lines in the background because they recede. This is one of the ways in which you create the illusion of depth.

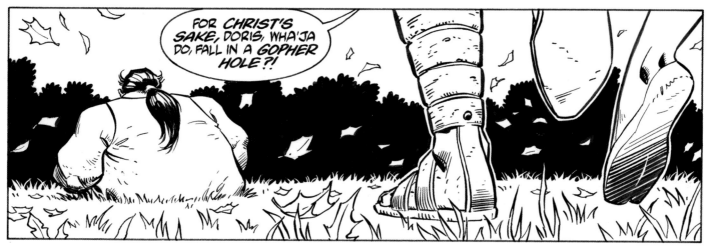

2 Add Brushwork and Final Touches

Apply the thicker brush lines with a no. 1 or 2 round for the contour of the strongman's leg and the girl's ankle. Add line weight to any of the pen lines that need it, for example, on the inside of the fat lady's left arm. Next, fill in the black areas. Save this for last because putting down large areas of ink can warp the paper a little and make it difficult to use the pen.

Add finishing touches with the correction pen, such as some blades of grass in the black area and a line in the gradation on the girl's foot. I love using white ink like this. It adds complexity to your inking, something that you couldn't achieve by just putting down black lines. Then all that's left is the erasing.

A wash tone is created by diluting ink with water to create weaker values of black. This is a great process for black-and-white printing, but it also looks very cool with color. Be careful; if the colorist treats it the same as regular line art, the results could be very muddy. Basically, they have to cut back on shaping with colors because the wash tones are doing most of that. For an example of a page I colored, see page 91.

DRAWING BEFORE ADDING WASH TONES

SET A SCENE WITH WASH TONES

I used three tones for this: light, medium and dark. The first thing to think about is where your light source is and how it's hitting objects. Start by shaping objects with the lightest tone. When filling in the lightest tone, fill in the areas that will contain the other two tones as well. As you apply the other tones, you are staggering them back, so you end up seeing each tone. This will create a natural progression of shading that goes from light to dark.

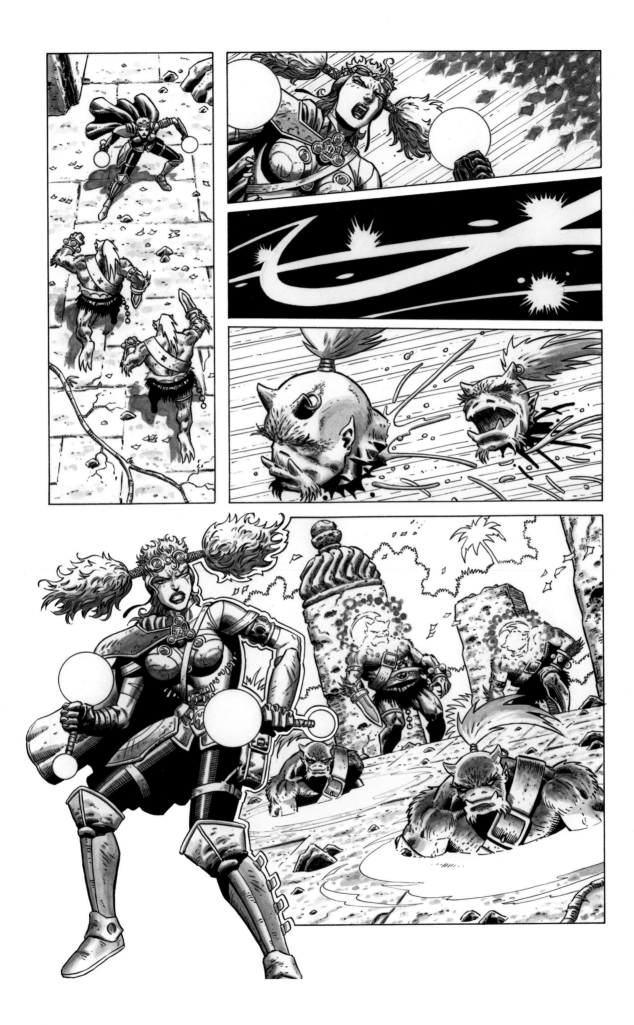

If you want to break into the comic field, self-publishing is a great way to get your work some attention. You have two options for this.

Mini-comic

Mini-comics are often smaller than standard comics, about 5 ½" × 8 ½" (14cm × 22cm), but they don't have to be. It's a relatively inexpensive way of putting some stuff out there, and that's always better than just spinning your wheels with nothing to show for it. It's also an interesting way to show people your work.

There are many ways you can create your mini-comic. Most are photocopied and stapled together to make a book. You could also print them out on your computer. Make sure you plan well, because you'll need to run the paper through twice to print the other side. You also need to have the pages in the right order so they read correctly when you put the book together. If you want a color cover, you can use a color copier or a color printer. Many people use a thicker paper stock for the cover.

Use a Printer

The second option is to use a printer and do a large print run. The two biggest comic printers are Brenner, and Quebecor. There are also many smaller printers that work with comics. Price them out and see what works best for your budget. If you contact printers, most will supply you with samples so you can choose the type of paper and process you want. Some may charge you for samples but will credit you if they do the printing. Sales representatives will walk you through the process, but remember to be as professional as possible.

Distribution is an important part of self-publishing, especially if you want to make enough money to do it again. Right now there's only one big company, Diamond Comic Distributors. They must first approve your book before they distribute it. They have a panel of people that review your material and decide if they will accept it. It's best to send them a printed book. If you don't have that, send a mock-up—a book you put together yourself. If you send a mock-up, make sure it's very well done. If they accept your book, there's a contract to sign for how much they will pay per book. To give you an idea of how things work, let's say your book costs $1 to print, so Diamond buys it for $2 and they sell it for $3. You also get a listing with an image in their monthly catalog, *Previews*.

There are a few small distributors: FM International and Cold Cut Distribution. One good thing about them is they keep your book available continuously for ordering. With Diamond your book is available only for the month that it's solicited. For more information, visit their websites at www.fminternet.com and www.coldcut.com.

Self-Promotion

Once you get your book printed and have some idea of when it will be distributed, you'll need to get the word out about it. For that you should send out a press release. You can also send your book to comic reviewers. If they review your book, that's great, because it's free publicity. Here are some places to contact:

www.sequentialart.com
www.newsarama.com
www.comicscontinuum.com
www.comicbookresources.com
www.comicsbuyersguide.com
cliff@comicshopnews.com

Mini-Comic vs. Printer

When you use a printer, they will store and deliver your books to the distributor for a small fee. Mailing the boxes yourself could be very costly. They will even send you some of your books so you can do promotional work. Contact them: www.brennerprinting.com and contact.magazines-catalogs@quebecorworld.com

Each company has guidelines for submitting work. In most cases these guidelines are posted on their websites. Check them out and follow the guidelines closely. Some may even allow you to e-mail your submission. There may be slight differences in what they ask for, but in general here's what they want:

- Photocopies, no originals

- Four or five panel pages showing your ability to tell a story and pencil correctly. Make sure your name, phone number and e-mail is on every page

- A short cover letter with all your contact information

It's very important to send only your best work. Try evaluating it from their perspective: Does it have enough backgrounds, does it have good establishing shots, is there anything awkward in the storytelling, are the pencils tight enough for anyone to ink? Whatever you do, don't start submitting until you have a good idea that your work is ready. I made this mistake and some editors remembered my awful samples for years, even though I was doing professional work. Go figure.

If an editor likes your work but does not have a job for you, keep in touch. If you have new and better samples, send copies. In most cases, if they don't hear from you they forget about you.

Get Some Credits

So, you know you're good enough, but no one will hire you. Here are a few ideas for what you can do:

- Make your own mini-comic. Who knows, the right person could see it and something could happen.

- Go to conventions, network with other artists, make connections and find out as much as you can about the business.

- Get some work in print, do a pin-up, a cover or short story, even if there's little or no money in it.

Landing a Job

If you do land that comic job, there are a few things to keep in mind so you don't mess it up. First off, be professional. That means when the editor tells you to do something or change something you say "OK" or "no problem." No amount of explaining is going to change what they want, and it's just going to make you look like a difficult artist. So whatever they ask, just do it, even if you don't agree with it. Take deadlines seriously, start the job right away and pace yourself. It's even a good idea to plot out on a calender how much work you need to do each day. As you work, you can feed pages to your editor five or six at a time. That way they can move the book along, which makes them happy.

Keep Moving

If you find yourself stuck on a job, don't procrastinate. Keep moving ahead; do one figure or one panel, anything to get you started. Before you know it, things will be back on track. A good first level for producing work is one page a day. Even if you can do more, I strongly recommend you to put that extra time into the quality of one page rather than doing another.

For your finished comic art, use two- or three-ply bristol board, cut into 11" × 17" (28cm × 43cm) sheets. You can buy 14" × 17" (36cm × 43cm) pads of bristol board and cut them down to the right size or buy 23" × 29" (58cm × 74cm) sheets. You can get three boards out of one sheet.

Be conscious of the surface quality of the paper because you don't want something with too much "tooth," the roughness of the surface.

Choose either vellum or smooth. Don't get plate, which is too smooth. Pre-ruled comic book boards are also available. Check with your local comic book or art supply store.

Using the Art Board Template

This is the final art board to be penciled, lettered and inked. Enlarge the art board template (shown on the next page) 175 percent for true scale or draw your own template using the dimensions provided. Use your lightbox to quickly transfer the rules from the template to your bristol board. Remember to use a non-photo blue pencil for the rules.

The inside dotted rule (including the indicia area) is the live art area. That means anything of importance, such as lettering or a focal character, should be within that space. The next dotted rule is the bleed dimension. Whatever you want to bleed off the comic page must extend over that line and go to the next outside solid rule. For double page spreads, notice the indications for cutting the inside edge of the left and right page. Then you just tape them together on the back.

The Layout Template

This template is used for creating the sketchy stage for your art. The layout template is easy because it is just a 6" × 9¼" (15cm × 24cm) area copied onto an 8½" × 11" (22cm × 28cm) sheet of paper. You can use regular copy machine paper, 20-lb. (43gsm). Just draw those dimensions and make enough copies in which to work.

10 1/2"

9 7/8"

5/8"

8 7/8"

1/2"

1/2"

13 7/8"

15 1/4"

15 7/8"

Indicia area

3/4"

3/4"

I hope this book helped your comic art in some way. Just keep at it, because the more you do, the better you'll get. If you do get discouraged or blocked, that's probably an indication that you need to learn more about something. Take a break from drawing pages for a few days. Learn more about whatever is giving you trouble. It may be hard to believe at times, but you'll improve. I think it has to do with getting some distance from your work and gaining a more objective perspective. Another thing I've found is every once in a while you need to step back and really assess your work. Ask yourself some questions:

- Would I buy a comic drawn like this?
- How is my work different from the books that I buy?
- If I were an editor or someone putting up money, would I use my work?
- If I were at a convention, would someone buy this page?

If you find you don't like the answers to some of these questions, that's a signal to make changes in your art. By periodically evaluating your work you'll become a much stronger artist.

Finally, here's my last pearl of wisdom, the three Q's of comics: Quality, Quality and Quality. The main thing that will get you more jobs is your past work in print. Don't blow your deadlines, but focus on quality, not quantity.

Good luck,
Vincent Giarrano